I am the daily Sun…I go forth hale, one whose name is unknown, I am Yesterday; one who views a million years; my name is one who passes on the paths of those who are in charge of destinies. I am the Lord of Eternity."

Going into the Light, 42

Ancient Egyptian Symbols

50 New Discoveries

Jonathan Meader & Barbara Demeter

Foreword by Hans Schneider

Jonathan Meader *Barbara Demeter*

Done Yesterday Press

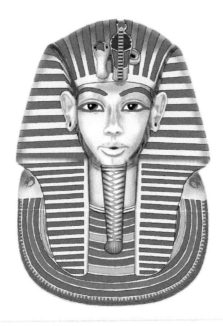

In honor of Egyptians, past and present.

Cover: Ancient Egyptians believed images, statues and mummies could be brought to life. Special ceremonies were designed to make that happen. This image of Tutankhamun's golden mask is "brought to life" by adding eye highlights and a little lip shadow, so he appears to be alive and speaking.

Ancient Egyptian Symbols: 50 New Discoveries <u>Abridged</u>

Text, photographs, drawings – Jonathan Meader. Original imagery initialed JM.

Barbara Demeter lovingly inspired, critiqued, shared, and supported this project.

Photographs used with permission:

Jürgen Liepe (JL) – 10, 27/34, 41, 48, 70-1, 89, 120.

Ken Landon –19-20 (3 photos).

Wikipedia – 19, 102.

Individual portraits on pages 122-3.

Done Yesterday Press, Marin, California, 2016

ISBN 978-0-9966833-4-0

Library of Congress Control Number 2016908007

"The study of ancient Egyptian religion serves as a mirror to our own consciousness." Jeremy Naydler (2: 19)

CONTENTS

 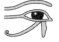

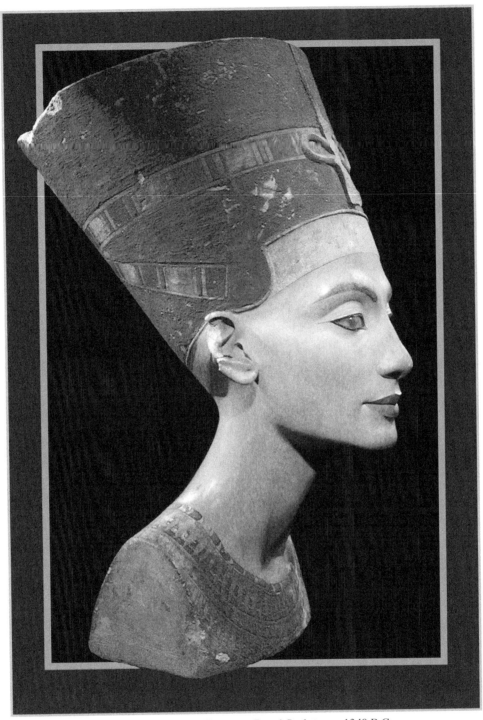

Queen Nefertiti, by Thutmose, Royal Sculptor, c. 1340 B.C.

Among the celebrities who have appeared in every society and have stood out because of certain talents and achievements, many have been artists. This is not surprising because they were the ones who saw what others could not see...they were innovators who changed the world. To a large extent, the Egyptians owed the vitality of their culture to the huge talents of their artists, the interpreters of Truth.

Life and Death Under the Pharaohs, pg. 12, Hans Schneider

FOREWORD

Ancient Egyptian Symbols: 50 New Discoveries is the joint work of Jonathan Meader and Barbara Demeter. They first presented their views on how to interpret Egyptian symbols in their article "On Closer Inspection: The Egyptian Blue Water Lily," published in 2004 in KMT, A Modern Journal of Ancient Egypt. Their present publication is the result of a long process of (in Jonathan's words): *"combing through the material and finding ways to clarify it. It is very exciting. The pieces fit together so well; 'coincidence' has played a large part, and things just seem to gravitate together."*

October 2002. I had just begun a sabbatical to do Egyptological research, when an email from Jonathan Meader appeared on my computer screen. I was in the middle of deciphering the difficult if not tedious, handwriting of a 15 year old French schoolboy who was later to become the decipherer of the Egyptian hieroglyphs: Jean-François Champollion. This manuscript caused me more problems than the hieroglyphic script of the Ancient Egyptians with which I had been familiar for more than 50 years. However, the text proved to be extremely interesting because it was Champollion's first attempt to decipher hieroglyphs. It was written in 1806 and contains an interpretation of hieroglyphs as signs of a symbolic script. It was only in 1822 that Champollion discovered the truth: hieroglyphs are not merely symbols, but also signs by which one may write the sounds of language, phonemes. I mention this because Mr. Meader's mail happened also to be dealing with – what a coincidence! – the interpretation and meaning of symbols and images used by the Ancient Egyptians! He raised complicated and difficult questions, but the suppositions he made as a basis for reasoning and a starting point for investigation, and his final conclusions or assumptions were fascinating and challenging, to say the least.

Since October 2002, Jonathan and I have exchanged innumerable letters about the interpretation of Egyptian symbolic representations. It stands to reason that the sources of information of the Artist-Egyptologist are in many respects different from the ones consulted by the so-called Scholar-Egyptologist. However, studying Jonathan's ideas and results of investigation, one realizes how important and refreshing it is to be open to the sources he explores. *"On closer inspection,"* Jonathan's maxim leads him to surprising explanations of the ways the Egyptians represented their world, explanations that are of great value, as the reader of the present book will discover. It is a matter of course that this book *"is designed to rely more on the images than the words"* as Jonathan once wrote to me. In Ancient Egypt images, expressions of art, were the magical instruments to shape and manipulate reality. In the words of the modern German painter Markus Lüpertz: *"Art explains the world – people forget that – art brings out the meaning of the world, and artists have helped God to create the world."* I pay my compliments to Jonathan and Barbara and thank them for their original, inspiring and innovatory contribution to the enchanting study of Ancient Egyptian Symbols.

Hans Schneider July 2011

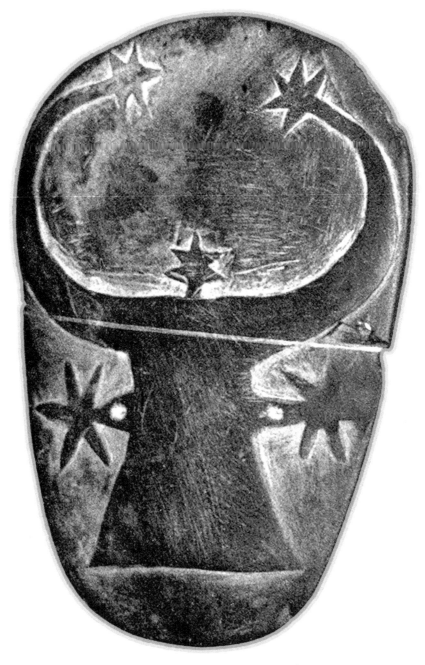

Star Dancer and Celestial Cow's face
Palette, c. 3500 BC

Religious teachings are attempts to put into the conceptual form of language notions which cannot be entirely rationalized — "truths" which are sensed rather than known.

Henri Frankfort (1: 41)

As for the Celestial Cow, she is the Sacred Eye.

Coffin Texts (335)

PREFACE

A seemingly impenetrable cloak of mystery still surrounds much of ancient Egypt, and some scholars suggest it may never be lifted. Many of the most important ancient Egyptian symbols, including a dozen major crowns, have defied identification...until now.

Meader and Demeter have discovered the sources and meanings for more than 50 of those mysterious symbols, and these discoveries greatly advance our understanding of Egyptian symbolism and mythology.

How could they make so many discoveries in a field populated with brilliant scholars, some of whom have studied these symbols for decades? Ancient Egyptians *"did not live in a world of concepts, but a world of images"* (Lurker, 7), and Meader's background is in visual arts. As an artist, he sees and thinks differently than many scholars. For example, the two Waterlilies were ancient Egypt's most sacred flowers, the source of the sun in myth, and yet this appears to be the first time they have been examined looking for the sun, or as possible sources of any other ancient Egyptian symbolism.

Meader and Demeter conducted detailed studies of both Waterlily species, researched ancient Egyptian symbols, and traveled to Egypt and to European museums many times to study and photograph examples of these symbols. They read translations of the Egyptian funerary texts and current books on Egyptian symbolism; presented research papers and slides at annual ARCE Conferences (American Research Center in Egypt), and corresponded with leading Egyptologists for years. The funerary texts and Egyptologists are quoted frequently.

A preliminary Egyptian Blue Waterlily study was shown to Egyptologist James P. Allen at the Metropolitan Museum, NY, and he generously offered to help. In 2004, those early findings were published in KMT, an Egyptology journal.

Meader's art has been exhibited internationally. He received a National Endowment for the Arts Printmaker's Grant and a Wurlitzer Foundation Grant. Two folios of his 4 silkscreen prints of pyramids, "Holding," 1974, are in the National Gallery, Washington D.C. His three published books are *The Wordless Travel Book* (pictures/ glyphs to point at when there is no common language), in print since 1995; *In Praise of Women*, Foreword by Isabel Allende, 1997; and *Good Year UTHR*, 2012.

Barbara Demeter is a business consultant who solves particularly challenging problems. My greatest debt is to Barbara, my inspiration and love, who made this book possible.

We are grateful to many people. Hans Schneider, a brilliant scholar with an open mind and generous heart, has been unwavering in his support. Ken Landon was very intuitive in selecting the waterlilies he kindly shipped to us. MarBina Rothblatt and Paul Mahon enthusiastically supported our project at a critical juncture. Without Herman te Velde and his brilliant, groundbreaking book, *Seth, God of Confusion*, our work could not have been completed. Jürgen Liepe gave us considerable latitude with his gorgeous photographs. Our dear friends Wagih and Hoda Issa and their family have shown us exceptional hospitality. Sincere thanks to Carol Andrews, James P. Allen, Jan Assmann, Robin Meader, Susanne Twomey, Richard Wilkinson, and LeRoy Montana for all their support and encouragement.

Similar forms, such as these two (1250 BC, 200 BC), seemed to fascinate ancient Egyptian artists.

Your time is limited, so don't waste it living someone else's life. Don't be trapped by dogma – which is living with the results of other people's thinking. Don't let the noise of others' opinions drown out your own inner voice. And most important, have the courage to follow your heart and intuition.

Steve Jobs

Nothing is more important than intuition.

Albert Einstein

INTRODUCTION

This is a 128 page abridgement of the original 334 page book: same discoveries, less text. Illustrations: 260 vs. 300.

One spring day in 2003, Barbara Demeter took home three blue waterlilies. She imagined she and her husband, Jonathan Meader, might try to solve an old mystery and discover why, in ancient Egyptian myth, the sun was said to rise from a Sacred Blue Waterlily.

It did not take long, for there in the middle of the first Blue Waterlily they examined, seated on a velvety yellow disk, surrounded by radiating yellow stamens and sky-blue petals, was a miniature, translucent, sun-like orb that appeared to be glowing. It was clear evidence of the ancient Egyptian belief that things that looked alike were connected (micro/macro).

After studying the 2 Waterlilies in detail, they searched for ancient Egyptian symbols resembling parts of those flowers. That search unleashed a flood of exciting discoveries, and the two Waterlilies soon proved themselves to be the foremost building blocks of ancient Egyptian symbolism.

A dozen major crowns were inspired by the Waterlilies, which as the source of the sun, Egyptians' premiere resurrection symbol, meant those crowns also symbolized resurrection. The crowns were not passive symbols, but rather resurrection machines designed to empower a person's resurrection.

Ancient Egyptians believed they discovered, not invented symbols. They imagined the Gods and Goddesses created *similarities* as clues for people to discover to help them understand creation and their place in it.

Ancient Egyptian Symbols: 50 New Discoveries is divided into three parts: "Ancient Egyptian Sacred Blue Waterlily"; "Ancient Egyptian Sacred White Waterlily, and "Mysterious Seth and the Eye of Horus."

In the last part, the complex natures of Seth and the Eye of Horus are fully identified for the first time. The source of chaos-god Seth's strange head, and its importance to Osirian mythology is revealed. His head was inspired, not by an animal, as has commonly been suggested, but rather by something inanimate, a farm implement.

Evidence, supported by the ancient funerary texts, clarifies Seth's role as the ancient Egyptian god of Death, and 3 distinguished Egyptologists agree. The Wedjat (Eye of Horus amulet) is identified as a symbol that appears to transform when it is either rotated or turned over. Interpretations and explanations of the Wedjat's unusual shape became defining features of Osirian mythology, which was the backbone of ancient Egyptian religion for more than 2000 years.

Visitors to "ancient Egypt" will have a more enjoyable and satisfying experience once they are familiar with the nature-based symbols in this book. They will recognize and understand much more of what they see.

Most of the information in this book cannot be found anywhere else.

Scholars tend to be more left brain (hemisphere) oriented.
Artists tend to be more right brain oriented.
The study of image-rich ancient Egypt requires both
because ancient Egyptians were both.

Left Brain – Right Brain

Left Brain		Right Brain
Logical	–	Intuitive
Linear	–	Holistic
Sequential	–	Random
Words and language	–	Symbols and images
Objective	–	Subjective
Knows object name	–	Knows object function
Math & science	–	Philosophy & religion
Cautious	–	Risk taker
Facts + logic = conclusions	–	Starts with answer

These are a few generalized differences between right brain and left brain orientation; **everyone uses a unique combination**. Whereas scholars tend to be more left brain oriented – they must read and retain vast amounts of material – this book approaches the study of ancient Egyptian symbolism more from a right brain perspective, that of a visual artist. Images were particularly important to ancient Egyptians and their written language, hieroglyphs, is even composed of them. *"Egyptians used the same word to refer to both their hieroglyphic writing and the drawing of their artworks"* (**W**ilkinson, 1: 10). Words and images were overlapping forms of communication, and when writing about the ancient Egyptian illustrated funerary texts, Egyptologist **G**oelet notes, *"The images had an innate potency greater than the power of the text accompanying them."* (**G**oelet, 148).

It's not what you look at that matters, it's what you see.

David Henry Thoreau

IMPORTANT

SUNS

The **Sun**, **Sun symbols,** and the two **Sacred Egyptian Waterlilies** are capitalized
in this book; the **sun** in a Sacred Egyptian Waterlily is not.

ABBREVIATED DATES

c. 1250 B.C.E. = •1250
c. 900 A.D. = 900•

QUOTATIONS

Ancient Egyptian Funerary Texts, quoted extensively in Part III,
are vital because they were written by ancient Egyptians.

PT – *The Ancient Egyptian Pyramid Texts*

Carved/painted in 10 Old Kingdom – First Intermediate Period pyramids.

CT – *The Ancient Egyptian Coffin Texts*

Painted on/in Middle Kingdom coffins.

GL – *Going into the Light* replaces *Book of the Dead*.

It is a more accurate title and a common near-death experience.
Written and painted on papyrus, New Kingdom – Ptolemaic tombs.

Recent book quotations:

Author's name + his or her book number (1–5) + page number.
Examples: **A**llen (1: 23) or (**A**llen, 1: 23)
Bibliography is on pages 120-1.

The first letter of every **Egyptologist's** last name is in **bold** type.

ANCIENT EGYPTIAN KINGDOMS

•3000	**– •2181**	**Old Kingdom**
•2182	– •2054	First Intermediate Period
•2055	**– •1650**	**Middle Kingdom**
•1650	– •1549	Second Intermediate Period
•1550	**– •1069**	**New Kingdom**
•1070	– •746	Third Intermediate Period
•747	– •332	Late Period
•331	– •30	Ptolemaic (Greek) Period
•30	– 395•	Roman Period

"As the Egyptians saw it, wisdom was the art of living righteously." Jan **A**ssmann (1: 56)

The purpose of all true symbols is to direct the individual away from the superficial concerns of life towards the center of existence...the true symbol always points beyond the here and now for it is a signpost to another world...each fragment points to the whole and everything ephemeral is in an image of the eternal.

Manfred Lurker (9)

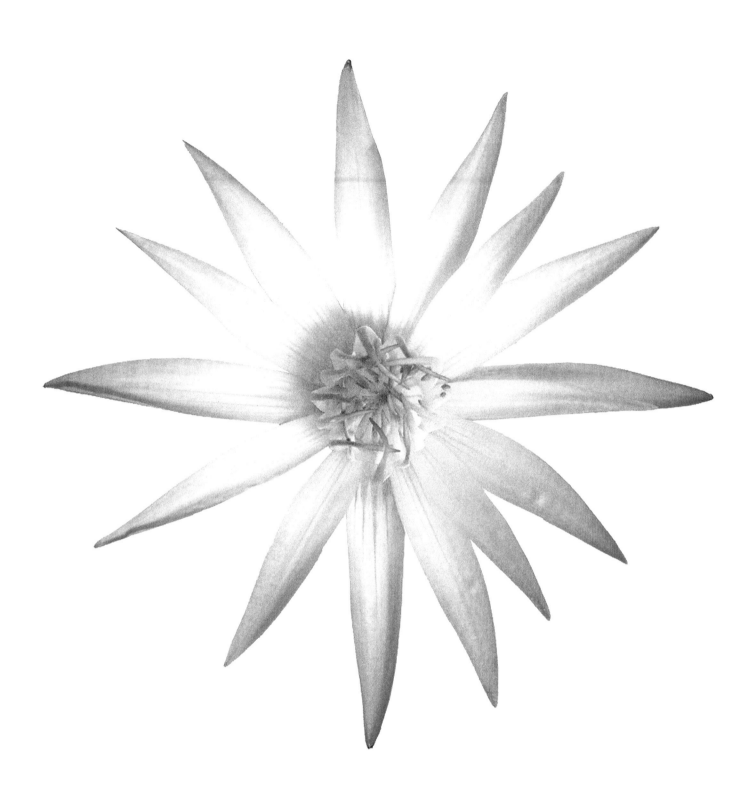

Ancient Egyptian Sacred Blue Waterlily

Anatomy, Habits, and Influence on Ancient Egyptian Symbolism

Ancient Egyptians believed things that resembled each other were related.

It was the foundation of their symbolism – symbols resembled what they represented. It was why, for instance, the Blue Waterlily was said to be the source of the Sun. *"At the primary level, the symbolism is direct, and **objects are shown in the forms they are meant to represent**"* (**W**ilkinson, 2: 30). By extension, *"the disk of the mirror was evocative of the sun – both in its brightness, and in its shape"* (ibid, 19). When scholars speculate about a particular ancient Egyptian symbol, they first try to determine what it resembles, and then decide if that identity makes sense.

*"**Of fundamental importance in understanding ancient Egyptian culture is the fact that Egyptian scholars and theologians saw the relationships between similar words or objects** as more than merely 'coincidental,' and **as a reflection of order, design, and meaning in the world.**"*

Richard **W**ilkinson (2: 126)

Parts I and II of this book each begin with a thorough examination of one of ancient Egypt's Sacred Waterlilies, first the Blue and later the White. Ancient Egyptian symbols resembling parts of those 2 Waterlilies are then identified, and their meaning and relevance considered.

*"One of the consequences of the Egyptians' belief that their language was a divine gift was a conviction that **a similarity between words** [images] **did not arise accidentally, but instead reflected an actual relationship which the Gods themselves had intended to be discovered by people.**"*

Ogden Goelet, Jr. (146)

*"The whole symbolic evocation rests upon the supposed...correspondence of things, on **the relationship between microcosm and macrocosm as intuitively understood by the mind and visually by the eye.**"*

Manfred Lurker (7)

*"**Similarities which seem irrelevant to our classification systems were considered significant by the Egyptians...it was through heka** [magic] **that an image could be made to stand for the real thing, a part could stand for the whole, and symbolic actions could have effects in the real world.**"*

Geraldine Pinch (16)

 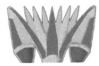 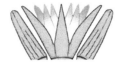 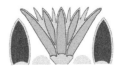 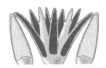

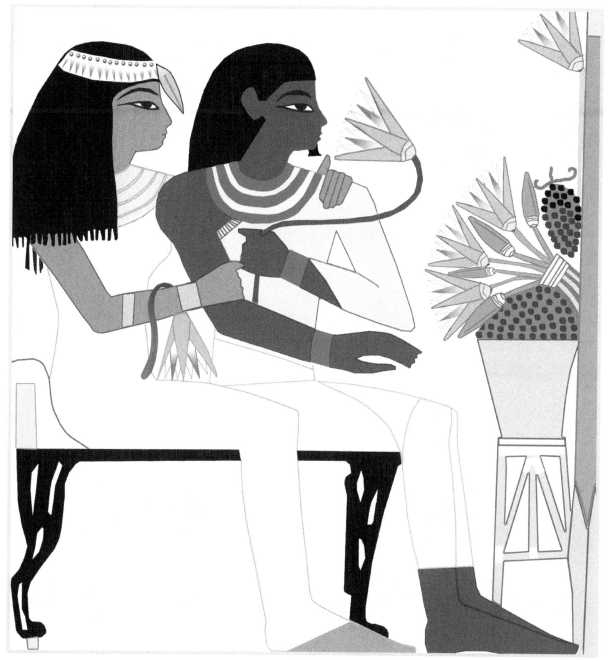

What was the Blue Waterlily's (Nymphaea caerulea) meaning to ancient Egyptians? This copy of a tomb painting (•1390*) includes the lady's Waterlily petal headband and the bud hanging over her forehead, the Waterlily bloom he holds in front of his face, and the Waterlilies on the grapes in front of them. Blue Waterlilies are ubiquitous in ancient Egyptian funerary art, and their symbolism is some of the most significant.

The Egyptian Blue Waterlily (Nymphaea caerulea), incorrectly referred to as a Lotus, has a central role as the source of the Sun/Ra in ancient Egypt's most beautiful creation myth. However, scholars didn't know why that particular flower was chosen, or even why it was considered sacred. This book began as a search for those answers.

* **IMPORTANT**: Dates are abbreviated: c. 1390 B.C. = •1390

Blue Waterlily

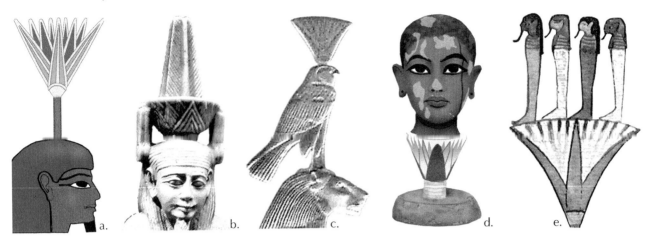

a. b. c. d. e.

Sacred Blue Waterlilies are sometimes used in combination with the Gods. a) Nefertem, the Blue Waterlily god, with a Waterlily on his head, •1310. **b)** A Two Feather Crown rises out of the Waterlily bloom on this Nefertum's head, •500. Counterpoises, which flank the crown, symbolize balance. A counterpoise normally hung behind a person to counterbalance a heavy pendant. **c)** A Waterlily on Horus as a falcon, standing on Nefertem as a lion, •100. **d)** Tutankhamun being born head first out of a Blue Waterlily, •1327. **e)** And, the Four Sons of Horus standing on a Waterlily, •1250. *"Be purified on top of your Waterlily in the Field of Rushes"* (PT, 512). A common misconception is that the Blue Waterlily retreats underwater at dusk, beyond a person's reach, to rise again with the first rays of the Sun. This fallacy appears in the writings of first-century Greek botanist Dioscorides, who wrote: *"They say the...head is altogether hidden under water, and again emerges at Sunrise."* When a Waterlily submerges after fertilization or 3 days, it doesn't resurface.

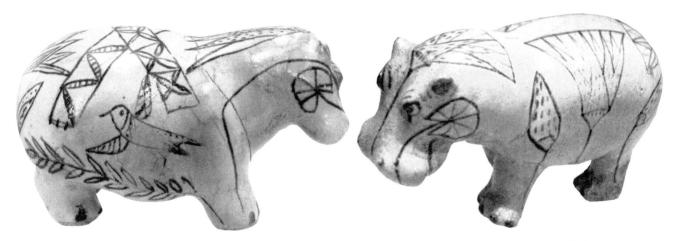

Why did Egyptians draw Waterlilies on these hippopotami sculptures? Hippopotami, Greek for "river horses," thrived in ancient Egypt. They could run faster than most people, weighed up to 7000 pounds and had razor sharp incisors. Hippopotami sank boats, mauled people, and destroyed crops when they came onshore to forage. Egyptians drew Blue Waterlilies on these models to calm all hippopotami with the Waterlily's sacred energy. They are colored blue for the same reason. Hippopotami are particularly docile when birds, usually oxpeckers, clean ticks and other insects off them, so birds are drawn on some models as well.

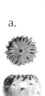
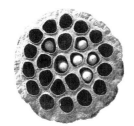
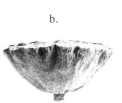
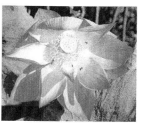

The Sacred Blue Waterlily (Nymphaea caerulea) is not a Lotus. a) The Blue Waterlily has a soft ovary, ~3/4" across (page 23), with ~2000 seeds. The **b)** Sacred Indian Lotus (Nelumbo nucifera) has a woody ovary, ~3 1/2" across, with 20~30 exposed seeds in hard shells (color photo detail: Meneerke Bloem, Wikipedia.com). When the Lotus first came to Egypt, •600, Waterlilies had already been flourishing there for more than a million years. Like the Blue Waterlily, the Lotus is beautiful, scented, valued as food, and open from mid-morning until mid-afternoon for 3 days. Both flowers rise spotlessly from the mire. Buddha is sometimes shown seated on a Lotus, meditating serenely in a Lotus position.

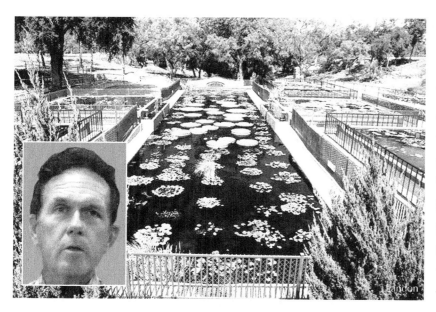

Ken Landon is the creator and director (inset) of the San Angelo International Waterlily Collection, Texas: *"The most magnificent collection of waterlilies in the world,"* writes Wayne Davis, president of the International Waterlily and Water Garden Society. In 2011, the Texas State Legislature designated a waterlily that Ken created, "Nymphaea Texas Dawn," as the official Texas State Waterlily.

Henry Conard and Ken Landon were the primary sources for this book's waterlily information. Conard was the foremost waterlily expert, and his book *The Waterlilies* (1905) is considered to be the waterlily bible. Landon is a leading expert today, with strong ties to Egypt. The Egyptian government requested his help identifying dried flowers found in ancient tombs, and after the construction of the Aswan High Dam wiped out the Waterlilies in the Delta, Landon supplied Egypt with millions of seeds of the 2 ancient species and helped with the replanting. He grew all the Waterlilies photographed in this book. They are the only 2 species known to have existed in ancient Egypt. Calling them Lotuses confuses them with the Sacred Lotus of India, an entirely different species of flower (top).

Blue Waterlily

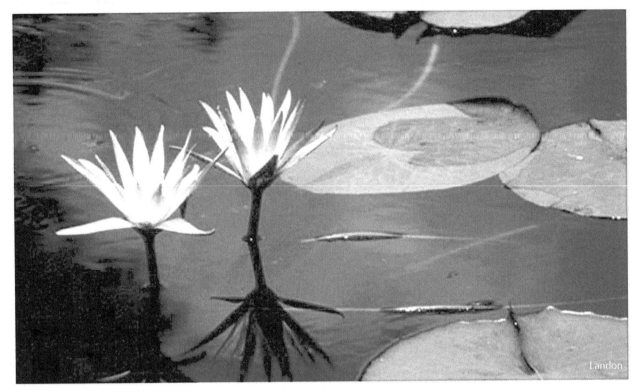

Egyptian Blue Waterlilies once flourished in tranquil pools fed by the Nile. They grow in water 1 to 5 feet deep and are open from approximately 10 a.m. to 3 p.m. The flowers are 2 to 8 inches in diameter and rise 3 to 8 inches above the water's surface for up to 3 days. They close at night, as do many flowers.

At the simplest level of observation, it is easy to see why Blue Waterlilies fascinated Egyptians. The blooms are beautiful and fragrant, with sensuous parts that move subtly in the changing light. They rise spotlessly from the mire and are only open for part of the day. When a Blue Waterlily's petals spread, an elegant cluster of long, yellow stamens with blue-violet tips is revealed. When those, in turn, have spread, seated on a golden disk is a perfect little translucent, Sun-like orb that appears to be glowing (opposite).

Ancient Egyptians thought the Blue Waterlily was related to the Sun by *resemblance*.

Blue Waterlily petals also appear to glow. Their color shifts from white at the center to blue at the tips, reinforcing a glowing effect. Plutarch, a first-century Greek, wrote that Egyptians believed the Sun: *"sprang every day fresh out of the lotus plant* [Waterlily]."

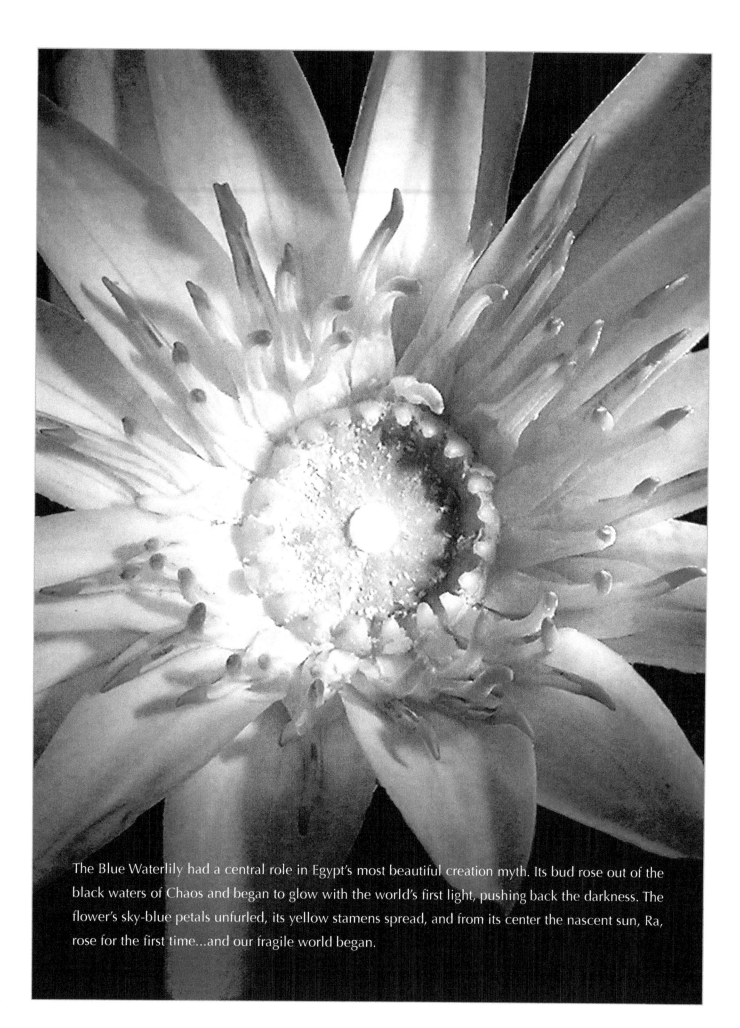

The Blue Waterlily had a central role in Egypt's most beautiful creation myth. Its bud rose out of the black waters of Chaos and began to glow with the world's first light, pushing back the darkness. The flower's sky-blue petals unfurled, its yellow stamens spread, and from its center the nascent sun, Ra, rose for the first time...and our fragile world began.

Blue Waterlily

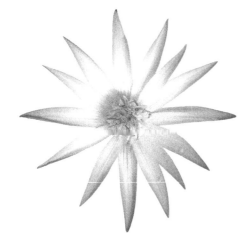

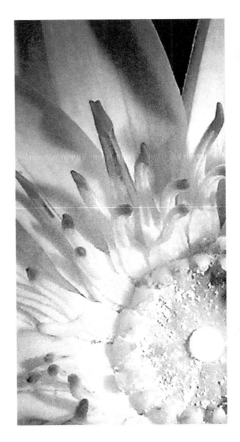

Petals

Stamens (m)

Styles (f)

Stigmas (f)

Floral apex (f)

(f) - female
(m) - male

I believe the true line of research lies in the noting and comparison of the smallest details.

Flinders Petrie (1853-1942, greatest Egyptologist)

Blue Waterlily Anatomy

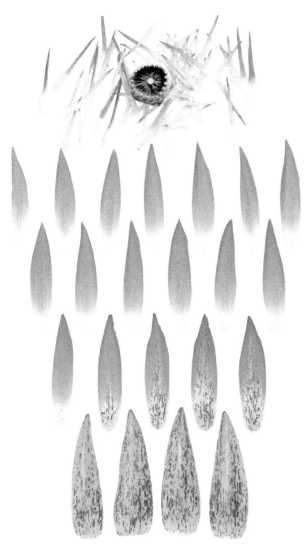

Petal tips

One of the Blue Waterlily's most significant features is its aroma, which emanates from its petal's tips. Therefore, images of Blue Waterlily petals, in part, symbolize the flower's scent. Egyptians believed that beautiful scents indicated the presence of Goddesses and Gods, many of whom played key roles in the resurrection process, which is one reason why so many images of Blue Waterlilies were included in tomb art. Since they were abundant in ancient Egypt and smelled wonderful, Egypt was thought to be the land of Goddesses and Gods. And, Egyptians' farms flourished because they were refreshed annually with a fertile flooding of the land, thanks to those Gods and Goddesses.

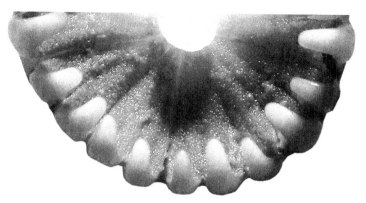

Blue Waterlilies had many practical uses for ancient Egyptians. The seeds were dried, ground into flour and baked into bread. The roots (rhizomes), rich in starch were eaten raw or cooked. The stems and leaves were used as animal fodder, and a variety of medicines was made from different parts of the plant. The Waterlily's *"root, which contains pain-relieving apomorphine alkaloids, was included in prescriptions for headaches, rashes and sores, stomach problems and constipation, and for a liver ailment"* (**A**llen, 5: 44). Egyptians also learned to steep parts of Blue Waterlilies in wine to create a powerful narcotic drink (soporific).

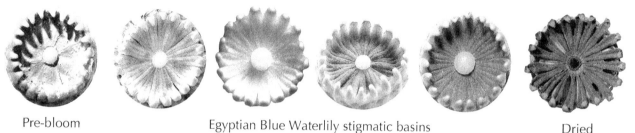

Pre-bloom Egyptian Blue Waterlily stigmatic basins Dried

The stigmatic basin, or top of the Blue Waterlily's ovary, is approximately 3/4" across, and its appearance can vary widely from flower to flower. *"There is great variation within a single species according to the food supply and other conditions,"* writes Conard (78). All the Waterlilies photographed in this book were grown at the same latitude (31°) as the Egyptian Delta, where they once flourished.

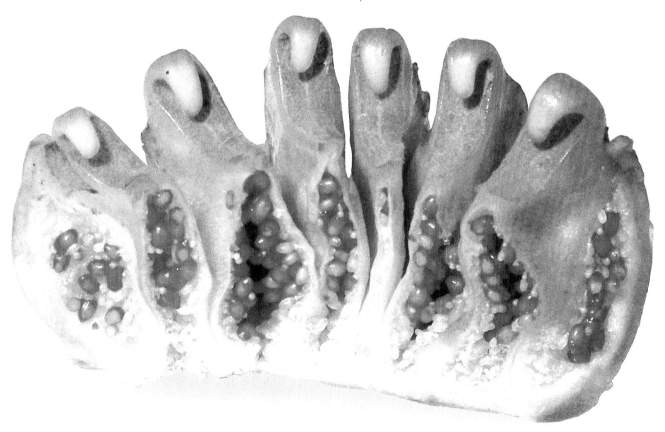

Blue Waterlily

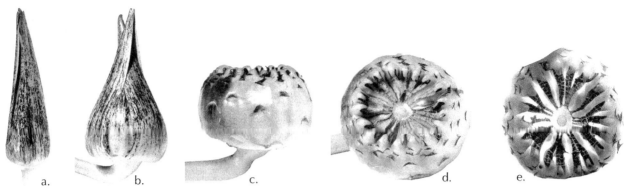

a. b. c. d. e.

After fertilization, the Waterlily's pod closes tightly and sinks to the bottom of the pond. a) A bud before blooming; its petals and stamens take up most of the room inside, and its ovary is tiny. **b**) The ovary swells considerably after being fertilized and then spending a month underwater. The sepals remain intact until the ovary is ready to release its seeds. **c**) Sepals removed. The Blue Waterlily devotes its energy to seed production, and the petals and stamens, no longer needed, shrivel into the brown stubs seen on the sides of this ovary. **d**) Top view of the stigmas starting to separate as the pod ripens. **e**) A slice of the ovary's top, backlit, shows the stigma just before the ovary releases its seeds. Because of its waxy consistency, the sun (floral apex) remains relatively intact, even after having spent a month or more underwater. The Waterlily sinks as soon as it is fertilized, or after 3 days.

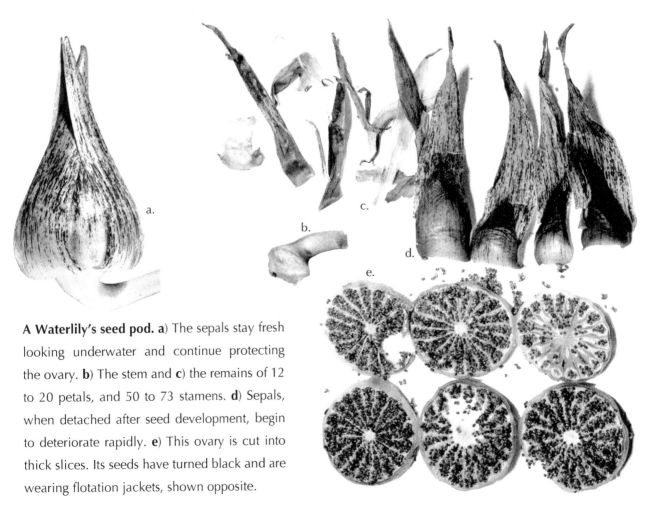

a. b. c. d. e.

A Waterlily's seed pod. a) The sepals stay fresh looking underwater and continue protecting the ovary. **b**) The stem and **c**) the remains of 12 to 20 petals, and 50 to 73 stamens. **d**) Sepals, when detached after seed development, begin to deteriorate rapidly. **e**) This ovary is cut into thick slices. Its seeds have turned black and are wearing flotation jackets, shown opposite.

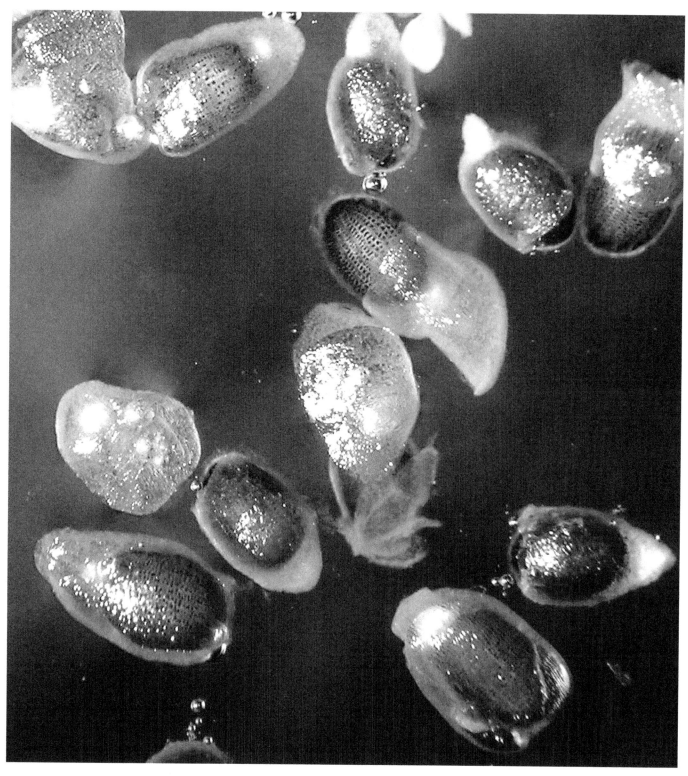

How does a Waterlily spread its seeds? These magnified Waterlily seeds, approximately the size of poppy seeds, each wears a translucent jacket, which keeps it afloat for up to 8 hours. That's long enough to drift away and sink in a new location. The seeds are so light that if caught in the Nile's current, they often ended up in the Delta, which was once flush with Waterlilies. The seed in the center of this photograph is slipping out of its jacket, which usually becomes waterlogged and sinks to the bottom before breaking apart and releasing the seed. These seeds are changing from red to black, but the microscope's intense light makes them look lighter and redder than they appear in daylight (opposite).

Seed
size

25

Waterlily Sun

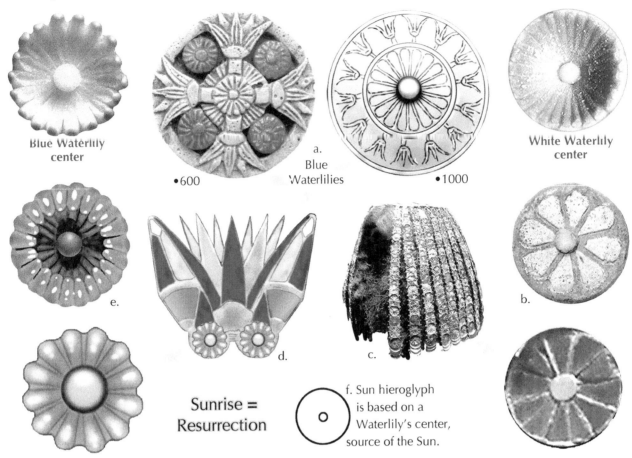

Blue Waterlily center

a. Blue Waterlilies

•600 •1000

White Waterlily center

e.

d.

c.

b.

Sunrise = Resurrection

f. Sun hieroglyph is based on a Waterlily's center, source of the Sun.

What inspired these ancient Egyptian disks (a-e), usually identified as rosettes and roundels? They resemble Egyptian Blue and White Waterlily centers (top corners). **a)** These 3 pieces each include 1 or more Blue Waterlilies. A White Waterlily's petals are wider and blunter. **b)** A tile piece with raised sun/Sun, •1100. **c)** A gold headdress, once having approximately 3600 carnelian inlay pieces, •1450. **d)** A gold and semi-precious stone Blue Waterlily flanked with buds, over a pair of Waterlily centers, •1250. The buds have orange carnelian bases to indicate a sun is glowing inside each of them. **e)** A realistic gold White Waterlily center and styles, •3000. **f)** It was not previously known what inspired the Sun glyph, but a Waterlily clearly did. The actual Sun does not have a circle at its center, but both Waterlilies do. The Blue Waterlily was known as the Sun's source, so it was logically the Sun glyph's source as well.

"Where the Sunset is inseparable from the thought of death, the dawn is a surety of resurrection."
Henri Frankfort (2: 109)

Dry Blue Waterlily center. This is the Waterlily's stigmatic basin. Its blackened sun, by resemblance, suggests the Sun will burn out one day. Egyptians, however, thought the Sun was eternal. Unfortunately, we will never get to learn much of their scholarship because a vast collection of scrolls was lost in the Alexandria Library fire of •48, and later in the Serapeum fire of 391•. A hundred thousand scrolls and books, or more are thought to have burned.

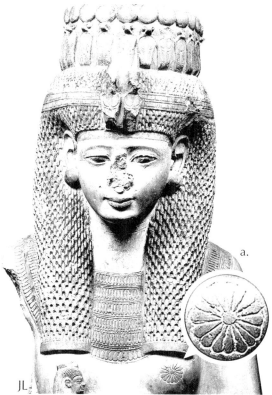

Why is there a Waterlily design on this statue's breast? a) A statue of Meritamun, daughter/queen of Rameses II, •1250, Cairo Museum. A Waterlily's center has replaced her left areola and nipple. Waterlily designs on statues' breasts first appeared in the Old Kingdom. They suggest that through the Queen's Waterlily-breast, Sun God Ra could nourish a future Pharaoh. **b**) Two Sun glyphs are part of this Shenu (royal name). They resemble swollen areolas and nipples (pregnancy/birth), which add nurturing and sensuality to the Sun symbolism.

Baby crocodiles nurse on inverted Waterlily's stigmas radiating down from the flower's center. When the amulet's threads are pulled, 5 baby crocodiles rise out of the Black Waters of Chaos' to nurse on the Sun's rays (stigmas). The artist created a face: the sun is Bes' nose, its rays form his mustache, the diamonds are his eyes, and he even has ears. Bes was a women's protective god, often depicted as a grotesque dwarf. Hidden and composite faces are important features of ancient Egyptian art.

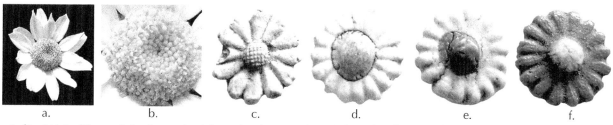

a. b. c. d. e. f.

Is it a Waterlily or daisy in ancient Egyptian imagery? a) A daisy has **b**) a rough, opaque center, and short petals. **c, d**) Two Egyptian (Amarna) faience daisies. **e, f**) Amarna daisies colored blue to suggest Blue Waterlilies. Egyptians may have had blue daisies. Creating one only requires that its stem, cut at a slant underwater, be kept in blue dyed water for a few days. A daisy looks similar to a Blue Waterlily, but lacks the Waterlily's aroma, beauty, translucent Sun-like orb, sky-blue petals, sacredness, and usefulness as food and medicine. Considering how awful cut daisies make water smell, one wonders why Egyptians depicted them at all. Perhaps it was a subtle criticism of Pharaoh Akhenaten (Amarna Period), who was widely hated after he outlawed all Gods and Goddesses except Aten (Ra), and then said Aten only spoke to him.

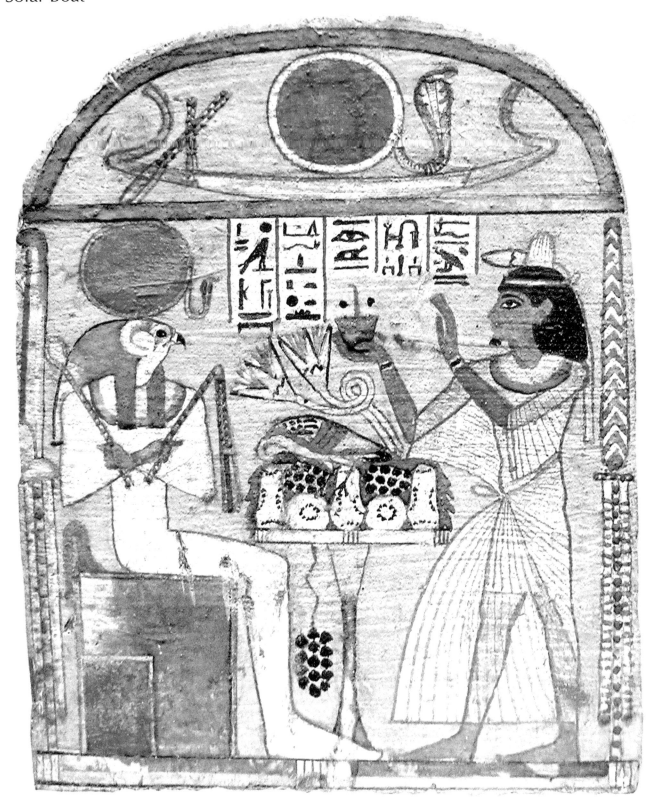

What inspired the ancient Egyptian Solar Boat? The Solar Boat was a particularly important symbol in Egyptian mythology because it carried the resurrected to their new homes among the stars. Some also chose to stay in the boat: *"I am in the bark* [boat] *of Ra forever"* (CT 150). Pictured at the top of this panel is a cobra-encircled Sun Disk riding in a Solar Boat, •900.

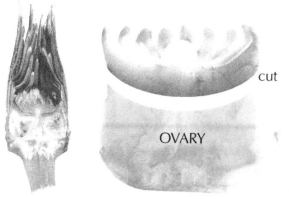

cut

OVARY

A Blue Waterlily's stigmatic basin as Solar Boat. The top of the Waterlily's ovary, or stigmatic basin, resembles a boat carrying the Sun. Since Blue Waterlilies were known as the source of the Sun, it was a natural connection to make. Stigmatic basins do float, and it would not have taken long for someone to notice that because Waterlilies were ubiquitous and grew in shallow water.

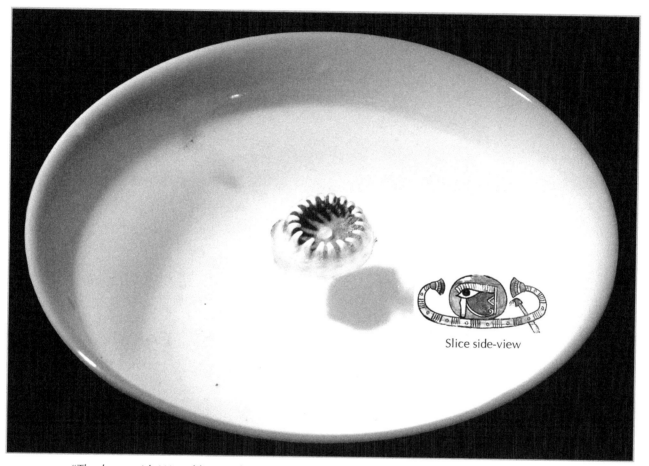

Slice side-view

"The boat with Waterlilies on her ends, I will ascend in her to the sky." Coffin Texts, 1030

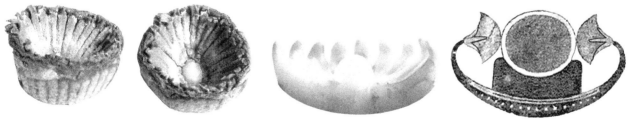

A dried "Solar Boat" can appear to be constructed of planks. A dried White Waterlily's ovary, with its sides shaved, looks like it's made of wooden planks. The drier an ovary is, of course, the better it floats. The yellow image is the top of a Blue Waterlily's ovary. To its right is a similarly shaped Solar Boat, with 2 Blue Waterlilies on its ends facing inward. The boat carries the symbol "Sun rising over the mountain."

Solar Eye

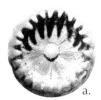 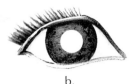 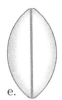 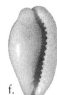

a.　　　　　b.　　　　　c.　　　　　d.　　e.　f.

What inspired the Solar Eye? a) A Waterlily's styles and their shadows suggest eyelashes. The orb at their center resembles a whitish-yellow translucent pupil, which is why *"Egyptians described the pupil of the eye as white"* (**L**urker, 129). The combination of sun/pupil and styles/eyelashes creates a Solar Eye. **b)** An eye with eyelashes and white/transparent pupil. **c)** A Solar Eye as Solar Boat. **d)** When rotated 90º, a closed eye outline becomes **e)** a sleeping eye or vulva. **f)** The Cowry shell was a vulva symbol in ancient Egypt, as in many cultures, *"because of its resemblance to the female genitalia"* (**A**ndrews, 42). The cowry's toothed edge resembles a Blue Waterlily's styles. Egyptians made and used amulets in many designs, primarily as magical protection. Art served the same function as medicine and magic (heka) – it employed supernatural power to affect the natural world.

Solar Eye examples. a) A White Waterlily as Ra's Eye. Its styles are more eyelash-like than a Blue Waterlily's. **b)** Four Eyes of Horus around a Blue Waterlily center create an eye shape, with its stigmas as the iris, and its sun as the pupil.

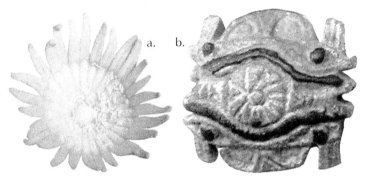

a.　b.

A*mong peoples having a mythical view of the world, the formative principle was not of logic but an outlook governed by images.*

Manfred Lurker (7)

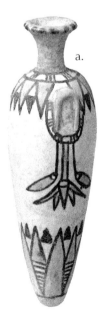

a.

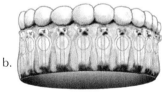

b.

c.

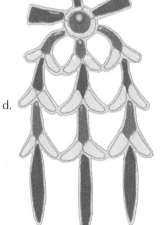

d.

Waterlily symbolism can be obvious, as with this **a)** Waterlily bud-shaped vase. Alternatively, it can be subtle, as with the 3 other images: **b)** a ring of cobras, each with a Sun on its head; **c)** a detailed scarab, and **d)** 3 fox skins with red snouts and bodies. The foxes have turquoise ears and legs and ultramarine necks and tails.

a. b. c. d. e.

A Blue Waterlily's stem also inspired symbols. a) It can remain semi-rigid for several hours out of the water. **b)** Air channels running the length of the stem supply air to the underwater roots. **c)** The stem's water-filled cells provide more support than would air-filled cells. **d)** Underwater, the stem begins to disintegrate *immediately* after the flower or bud has been cut off. When the flower has finished blooming after 3 days, it closes tightly into a seed pod (page 24). The stem then pulls the pod to the bottom, where the pod sits upright (page 44) as its seeds develop. **e)** Tiny 3, 4, and 5-spiked crystals can form in Waterlily stems as they dry.

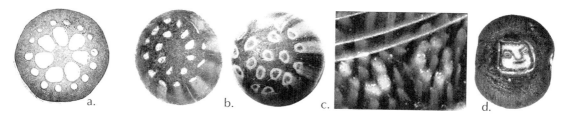

a. b. c. d.

A cross-section of a Waterlily's stem was the inspiration for these **b)** two millefiori game pieces, and **c)** this piece of a millefiori glass bowl. Millefiori means a "thousand flowers" in Italian. That technology did not arrive in Egypt until •30. It is a glass process whereby the desired design is created as the end-view of a group of different colored glass rods and strips (below). **d)** This face was wrapped in brown, white, blue, and variegated red glass strips, then heated and stretched. It fused into a single narrow rod with the face as its end-view, then sliced into short pieces, reheated and rounded and used as **b)** game pieces. **c)** Other slices were melted together on a hot bowl mold. Glass making in Egypt began in •2500 with glass bead production. **d)** Faces were a popular millefiori bead subject. This one is just 1/2 inch wide.

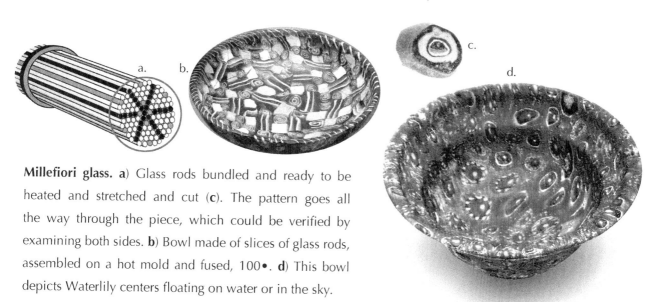

a. b. c. d.

Millefiori glass. a) Glass rods bundled and ready to be heated and stretched and cut (**c**). The pattern goes all the way through the piece, which could be verified by examining both sides. **b)** Bowl made of slices of glass rods, assembled on a hot mold and fused, 100•. **d)** This bowl depicts Waterlily centers floating on water or in the sky.

Four Colors

Four Colors were used to magically induce Sacred Waterlily rising Sun power. Waterlilies and other symbols were sometimes painted in 4 specific colors: yellow, red, light blue/green, and dark blue/green. Together, these colors symbolized the Blue and the White Waterlilies, and Egyptians used them to positively influence reality. Each color by itself also had important symbolic value.

Yellow = Sun, Waterlily stamens **Blue/green** = Blue Waterlily, sky, water

Red = White Waterlily, Sun **Dark blue/green** = leaves, night, water

The Blue and the White Waterlilies were important sources of Egyptian symbolism, and this combination of 4 specific Waterlily colors remained in use for several millennia. Egyptian paints were not standardized, and there was considerable variation in their colors; however, one can usually recognize when the Four Colors were intended. Egyptians artists used mineral-based paints for lasting color (vs. organic, which fade), and some of their paintings are still vibrant after 3000 years. Much surviving Egyptian art is funerary because kings' tombs were usually deep underground, where it was protected from the elements.

Opposite: **A masterfully detailed coffin in Four Colors.** She wears 2 large collars of Waterlily petals and 1 of Waterlily blooms. The Winged Scarab, standing on a symbol meaning "eternal wealth," is pushing up a Sun encircled by 2 cobras. Her skin, and the sacophagus' base color is golden – the color of the Sun.

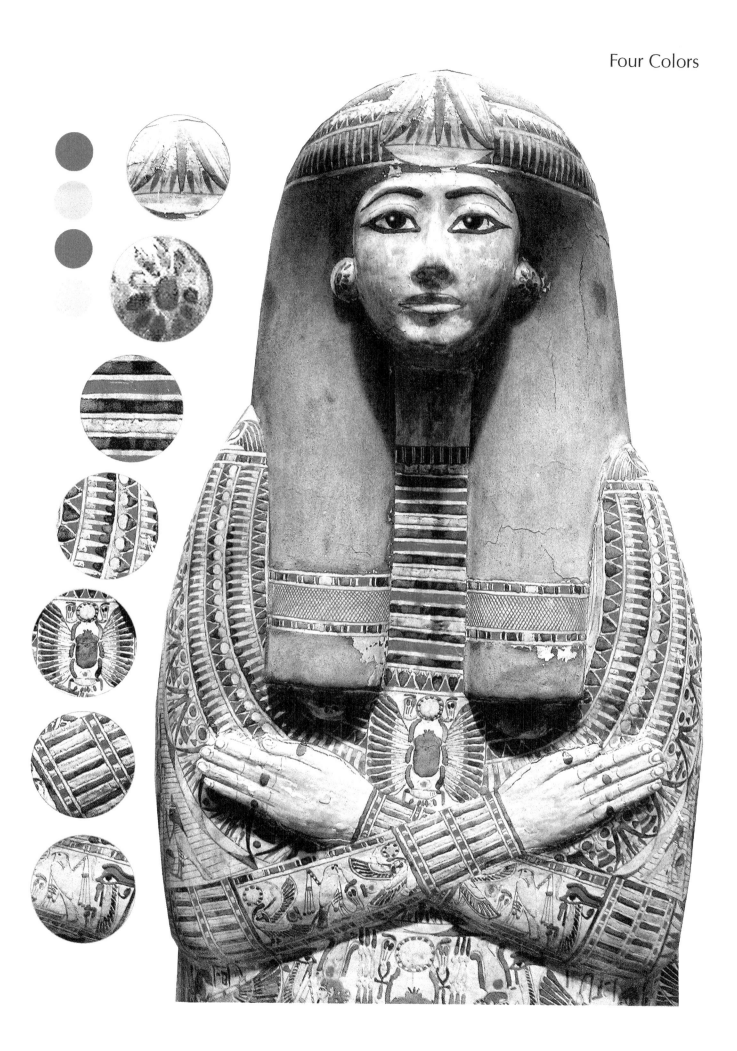

Cobra-Ring Crown

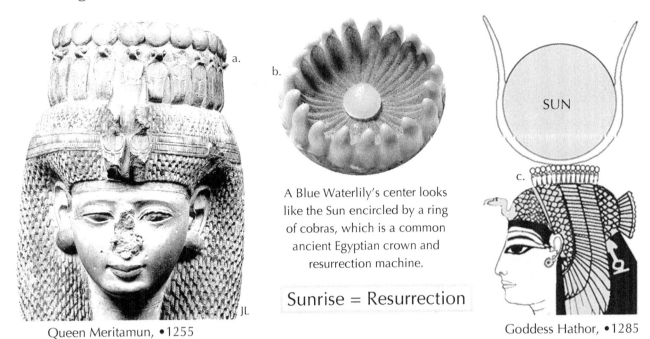

a.

b.

A Blue Waterlily's center looks like the Sun encircled by a ring of cobras, which is a common ancient Egyptian crown and resurrection machine.

SUN

c.

Sunrise = Resurrection

Queen Meritamun, •1255

Goddess Hathor, •1285

What inspired the Cobra-Ring Crown? a) An ancient Egyptian crown consisting of a ring of realistic cobras, each with a Sun on its head; its large, central Sun is missing. The **b)** center of a Blue Waterlily looks strikingly like a ring of cobras, with small heads, flaring chests, and facing the sun at their center. **c)** Hathor wears a Cobra-Ring crown. Each cobra has a Sun on its head, with a larger Sun rising above them. Sunrise symbolized resurrection – the Sun had survived its challenges in the underworld and been rejuvenated and reborn. The Blue Waterlily's stigmatic basin and sun (**b**) clearly inspired the Cobra-Ring Crown.

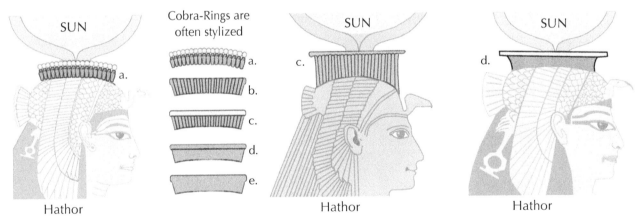

SUN

a.

Cobra-Rings are often stylized

a.
b.
c.
d.
e.

SUN

c.

SUN

d.

Hathor

Hathor

Hathor

Stylized Cobra-Ring Crowns. Detailing every cobra in a Cobra-Ring Crown was labor intensive, expensive, and not essential because a stylized symbol was thought to be, potentially, as effective as a realistic one. Five Cobra-Ring Crown stylizations are: **a)** roughly outlined cobras with individual Suns; **b)** cobras as vertical bands without Suns; **c)** cobras as vertical bands with their Suns forming a horizontal band above them, often yellow; **d)** an empty Cobra-Ring outline with a horizontal band symbolizing Suns, often yellow, commonly called a Platform Crown, and **e)** an empty outline. Each Hathor wears a vulture crown with a stylized Cobra-Ring, above which a large Sun Disk rises. The term **Cobra-Ring Crown** replaces **Uraei Kalathos** (Greek for "royal cobra basket"), which is limited to "realistic" and "stylization (**a**.)"

3 Cobra-Rings

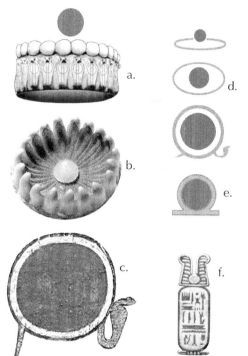

a.

b.

c.

d.

e.

f.

Cobra-Rings are composed of 1 or more cobras. All Cobra-Rings symbolize protection (cobra) and resurrection (Sunrise). **a)** A Cobra-Ring Crown from the side. **b)** A Blue Waterlily's stigmatic basin, which inspired **a** and **c**. This **c)** Cobra-Ring is a Solar Disk encircled by a single cobra. **d)** The brown rings symbolize 1 or more cobras around the Sun. Two related symbols are **e)** the Shen symbol, which symbolizes eternal Sun/life, and **g)** a snake biting its tail to form a closed loop. **f)** A Shenu (~~cartouche~~), which encloses a royal name, is an elongated Shen. Another Solar ring Egyptians experienced was caused by ice crystals in the clouds and meant that storm-god Seth was rapidly approaching.

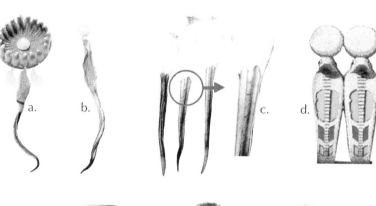

g.

A Blue Waterlily stamens and styles both resemble cobras. a) Stamens attach at their widest end. **b)** Waterlily stamens and sun. **c)** "Green ones" was the name for their (brown) cobras. The stamen's spine was **d)** included on many cobra images. It often divides the oval on the cobra's chest.

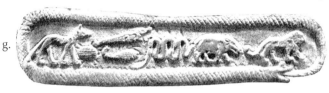

a.

b.

c.

d.

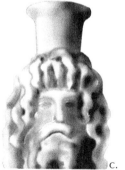

a.

b.

c.

d.

e.

A stylized Cobra-Ring Crown resembles a modius (c), or Roman grain measure equal to 1/4 bushel or 2 gallons. Scholars call it a modius, but Egyptians were using that symbol 2000 years before Rome existed. **a)** A stylized Cobra-Ring Crown on her head, •1250. **b)** Bottle mouths as stylized Cobra-Rings increased the life energy of anything that flowed in or out, •1400. **c)** A Roman-Egyptian sculpture of Sarapis with a modius on his head, 100•. Bottle lips **d, e)** were sometimes colored yellow to emphasize their Cobra-Ring/Sun connection, •500 and 100•. **All circles and spheres were related to the Sun by resemblance.**

Cobra-Ring

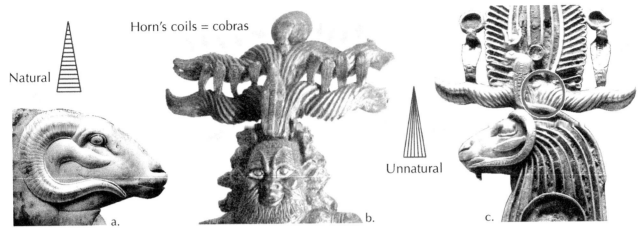

Natural

Horn's coils = cobras

Unnatural

a. b. c.

Some horns were sometimes altered to resemble Cobra-Rings. **a**) An ancient Egyptian relief of ram god Khnum with the ridges on his horns depicted realistically, going side to side. **b**) The horn's ridges on this Bes run vertically, unnaturally, but by doing so suggest cobras in a ring. Perfectly illustrating that, Bes' horns transform into 9 cobras (plus 1 one in front). **c**) Khnum's horns' ridges rise vertically out the top of his head, then coil to appear more natural. Egyptians altered the horns to add Cobra-Ring resurrection symbolism.

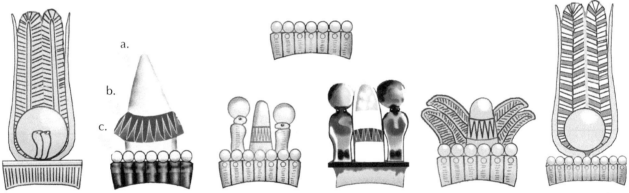

a.

b.

c.

A Queen's Cobra-Ring Crowns. These are all crowns that Tutankhamun's queen, Ankhesenamun, is depicted wearing, •1330. Each includes a few common elements: the middle 4 lower crowns each has **a**) a central Resurrection Bud (discussed later), **b**) a Blue Waterlily petal collar, and rises out of **c**) a Cobra-Ring. These usually include an additional, larger cobra or vulture's head in front.

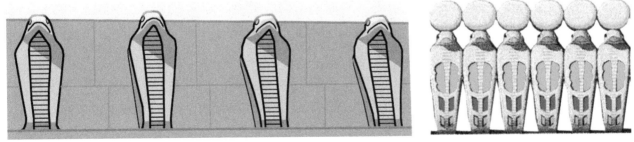

Cobra-Rows. One of the earliest examples of a Cobra-Row, or frieze, is the one (left) on top of a wall in King Djoser's pyramid complex, designed by Imhotep, •2650. Cobras are usually nocturnal and solitary, but their inspiration came from the Waterlilies, a source so dominant that Egyptians were willing to alter the cobras' nature and have them appear in groups. Some Cobra-Rows are intended as side-views of Cobra-Rings.

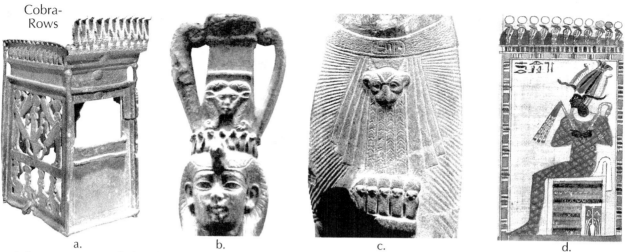

Cobra-
Rows

a.　　　b.　　　c.　　　d.

Cobra-Row use varied widely. a) A model bronze shrine with Cobra-Rows on top. **b)** Part of a sistrum (rattle) handle with a realistic Cobra-Ring on the lower figurine's head and a stylized one on Hathor's head above it. Hathor's hair falls in 2 curls that resemble her horns. **c)** The sash hanging from the king's waist is trimmed with a Cobra-Row, to protect and empower his seed. **d)** A realistic Cobra-Row over one stylized as a cornice, with another, further stylized as a simple banded border in Four Colors. It's all Waterlily inspired symbolism.

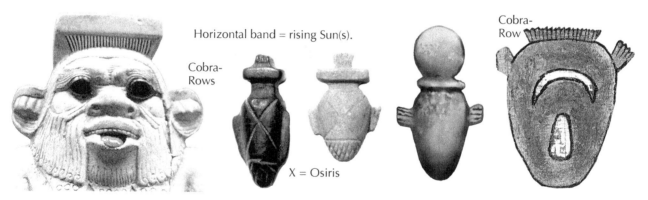

Horizontal band = rising Sun(s).

Cobra-
Rows

Cobra-
Row

X = Osiris

Cobra-Rows on Bes and 4 hearts. Each of these 5 symbols has a stylized Cobra-Row on top. The bronze heart has a large Sun rising above its Cobra-Row. The red heart looks distressed; concerned its weight may be too great for it to resurrect. To fully resurrect, one's heart must be lighter than a feather of Maat (Justice), which was determined at the deceased's Weighing of the Heart Ceremony. Besides Waterlily symbolism, this heart includes face, crescent moon, egg and red symbolism, and its ears resemble Hathor's cow ears.

Cobra-Rings were often used in combination with other crowns.

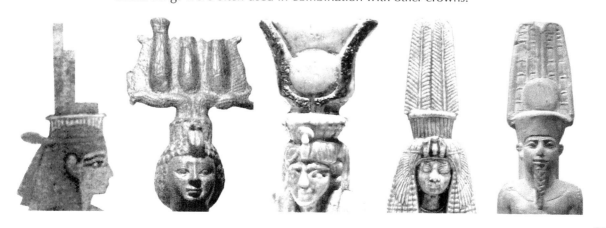

Waterlily Petals

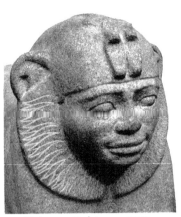

Taharqa Sphinx, •675

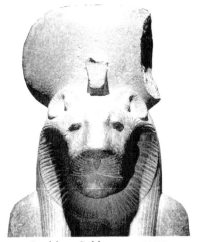

Goddess Sekhmet, •1370

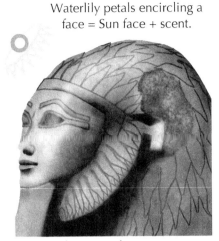

Waterlily petals encircling a face = Sun face + scent.

Hatshepsut Sphinx, •1495

What significance do radiating Blue Waterlily petals around a statue's face have? They imply that face is the Sun because there is a sun at the center of every Waterlily. Sun symbolism empowered resurrection. Lioness Sekhmet is Ra's daughter, and her face can block part of the Sun Disk because she is part Sun symbol – the Eye of Ra. Sphinxes are part lion, reinforcing their connections to Sekhmet and Ra.

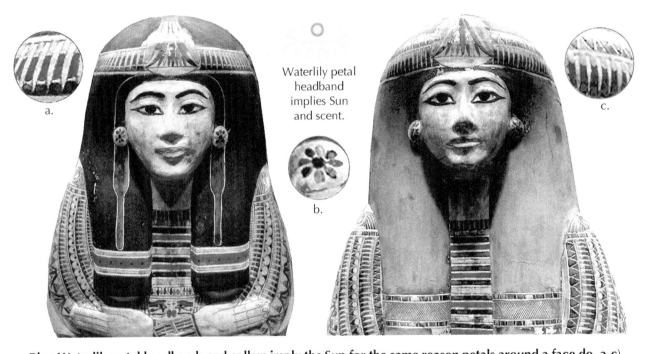

a.

b.

c.

Waterlily petal headband implies Sun and scent.

Blue Waterlily petal headbands and collars imply the Sun for the same reason petals around a face do. a-c) Most of this painting was done in Four Colors. **b)** Their earrings resemble a Waterlily's stigmatic basin, its petals, and a cross-section of its stem. The Sun Disk was Egyptians supreme resurrection symbol, but only Goddesses, Gods, and royalty were depicted with one over them. Everyone else had to imply the Sun's presence, which they did with Waterlily petal collars and headbands. Symbolically fragrant Waterlily petals implied the Gods and Goddesses were present. There were no second chances at resurrection, so Egyptians included as much positive resurrection symbolism as they tastefully could. Egyptian artists worked in poor light, with rudimentary tools and pigments, yet much of their art is of an exceptionally high esthetic quality.

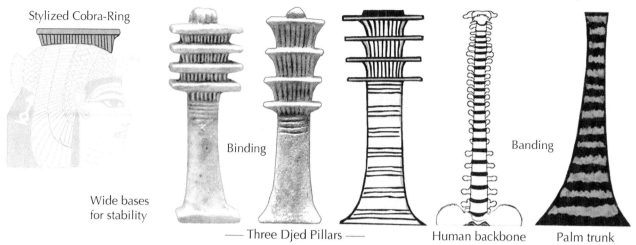

Stylized Cobra-Ring

Binding

Wide bases
for stability

—— Three Djed Pillars —— Human backbone Palm trunk

Banding

What are the mysterious shapes at the top of Djed Pillars? They resemble stylized Cobra-Rings. The Djed (silent D) Pillar is mentioned in the funerary text *Going into the Light* as Osiris' backbone. One was sometimes painted on a coffin bottom in line with the deceased's backbone, to empower his or her resurrection. It symbolized *"the power in which the energy of the grain was preserved"* (**L**urker, 47), i.e. life force. The top of the Djed Pillar resembles a stack of Cobra-Rows, which often include the same vertical banding. These bands appear to have been part of the original design: *"Two three-dimensional Djed Pillars, in ivory, found in Early Dynastic tombs at Helwan (•2900), featured the vertical bands you refer to – and these are amongst the earliest attestations of the symbol"* (Neal **S**pencer, British Museum, correspondence, 10/08). Cobra-Rows are powerful resurrection machines, and a stack of them super-charges the deceased's resurrection. The Djed Pillar first occurred as a 2-D wall design in Djoser's complex, Sakkara, •2650 (**A**ndrews, 83). Waterlily resurrection symbolism was difficult to improve on because of its many positive associations.

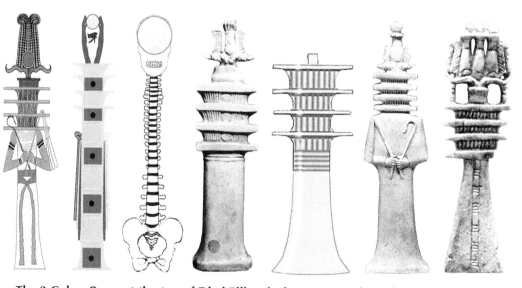

The 3 Cobra-Rows at the top of Djed Pillars is the same number of days a Waterlily blooms (Sun rises). Djed Pillars often include a rising Sun(s). The green Djed Pillar has a Sun above each Cobra-Row (courtesy Didier Wormser, Paris). Gold is the Sun's color and the most powerful resurrection color. The Djed Pillar on the coffin cuts the jackal, a death symbol, in 2 to disable it. The seahorse on its shoulder forms a Sun glyph with its coils (page 96).

Sunrise

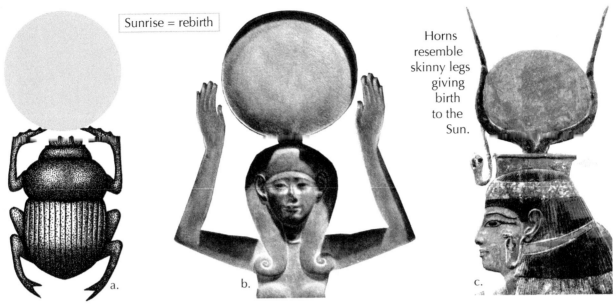

Sunrise = rebirth

Horns resemble skinny legs giving birth to the Sun.

a. b. c.

What was so special about Sunrise? That's when resurrection occurred. These all appear to be pushing up the Sun. **a)** The Khepri (Scarab) was ancient Egypt's most common amulet. The actual beetle rolls a dung ball around with its hind legs, finally burying it. The female beetle first lays an egg in some balls, and later a new beetle seems to emerge miraculously from the ground. This reminded Egyptians of the Sun and Sunrise, which Scarabs came to symbolize. **b)** Nut, sky Goddess and mother of Osiris, Isis, Seth, and Nephthys, swallows the Sun at Sunset and gives birth to it at dawn. She sometimes accompanies the resurrected to their new homes among the stars. **c)** Hathor with her crown of resurrection symbolism.

Opposite: **What Waterlily/Sun symbolism is in Tutankhamun's pendant** (top to bottom). **1)** Gold crescent moon with black Sun. **2)** Eye of Horus in a Solar Boat. **3)** Two Cobras with Suns. **4)** Multiple Four Color use. **5)** Light green Winged Scarab with large **6)** Heraldic Lily, **7)** Blue Waterlilies, and a **8)** Shen/infinity sign in its talons. **9)** Two Uraei with Suns over them. **10)** Orange and blue Sun Disks. **11)** Six blue disks with gold Waterlily centers. **12)** Three large and 4 small Waterlily blooms and 2 buds. Orange mandrakes on both ends of the bottom row. **13)** There are also 8 orange Heraldic Suns in the Scarab's tail. Cairo Egyptian Museum, •1337, 6 inches tall. Photo by Jürgen Liepe; black background added.

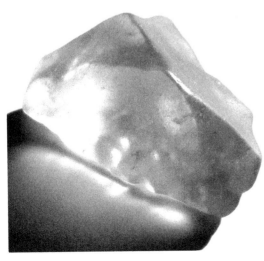

This piece of translucent Libyan desert glass, like the Blue Waterlily's sun, has an "illuminated shadow." Recent research suggests a gigantic meteor exploded above the Libyan Desert 28 million years ago. Exploded above, rather than impacted, because of the tremendous heat generated over a vast area and the lack of a crater. Libyan Desert glass is 98% pure silica and requires heat of 1800° C. to form (lava flows at 1100° C). An ocean grew over the meteoric glass, then, once the water had receded, sand and wind smoothed it. The Scarab centerpiece in Tutankhamun's pendant is made of Libyan Desert Glass.

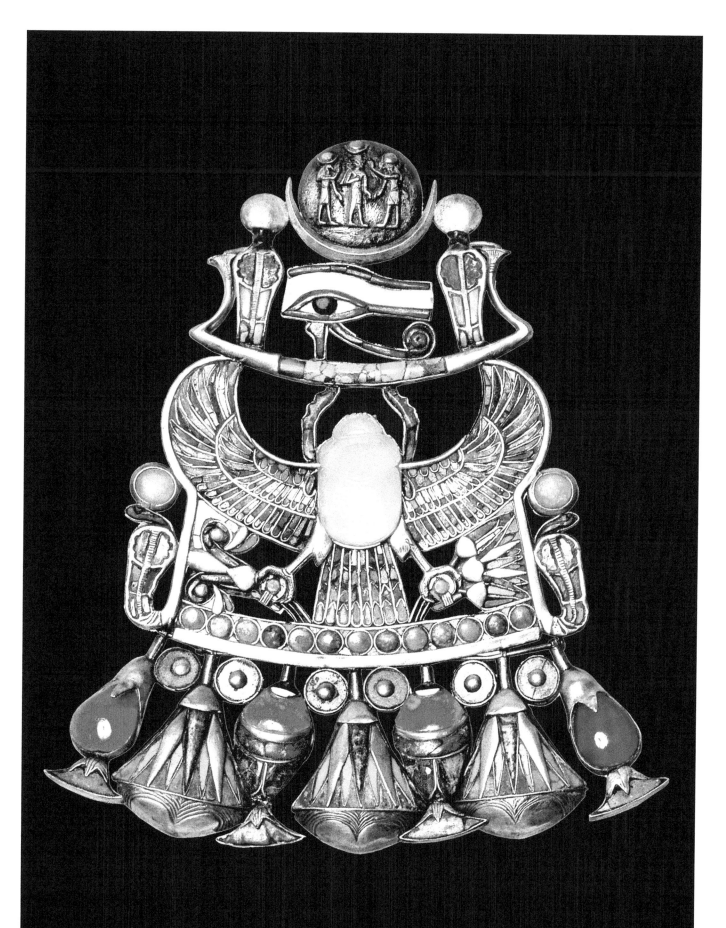

Heraldic Lily

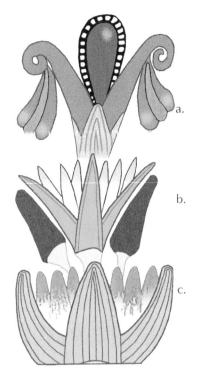

Heraldic Lily, Blue Waterlily, and White Waterlily.

(copied from an ancient Egyptian painting)

a) **Heraldic Lily** side-view with 2 opposing petals and a red, inverted, tear-shaped sun rising between them. It's a stylized Blue Waterlily.

b) **Blue Waterlily** side-view with flanking buds. It's more realistic than the Heraldic Lily. Sun implied but rarely shown.

c) **White Waterlily** side-view with wider, blunter petals than the Blue Waterlily. Actual Sacred White Waterlilies may have some red on their sepals, a bit under their stamens, and a blush on some petals, but no red/orange tips.

Heraldic Lilies and Blue Waterlilies were used interchangeably in art, and White and Blue Waterlily features were often combined (page 55).

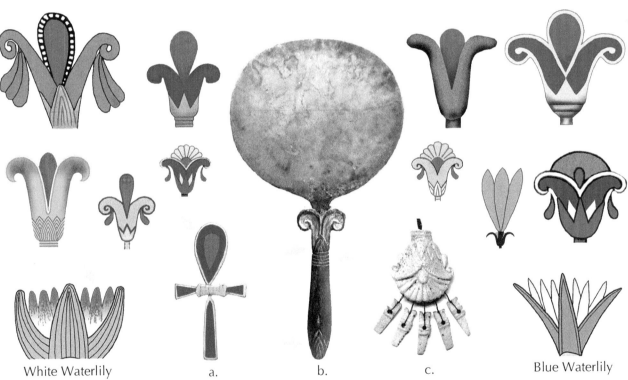

White Waterlily a. b. c. Blue Waterlily

Heraldic Lilies and Waterlily blooms are depicted in profile. The top 2 rows above are Heraldic Lilies, most of which have Waterlily sepals. **a**) A tear-shaped Sun is part of an Ankh. It is used in many other situations, as well. **b**) A Heraldic Lily handle with a Sun Disk mirror. **c**) An inverted Heraldic Lily amulet with 5 baby crocodiles that nurse on the sun/Sun's rays (stigmas) when the threads are pulled. This White Waterlily has orange-tipped petals, so they resemble incense-cones, implying scent, which was particularly important to ancient Egyptians, but which the White Waterlily lacked.

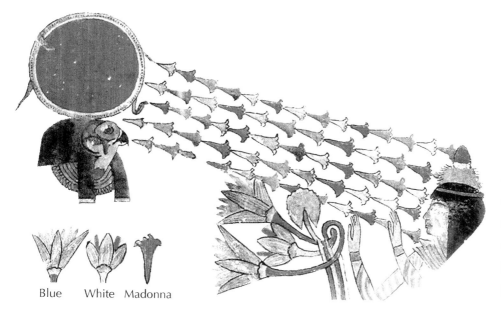

All Egyptian lilies were not Sacred Waterlilies. Strongly scented, multi-colored Madonna Lilies shower down on this woman from the Cobra-Ring/Sun Disk on Ra-Horakhty's head, •600.

Blue White Madonna

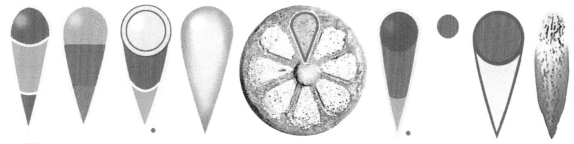

Waterlily Heraldic Sun symbols. Ancient Egyptians used the Heraldic Lily's teardrop Sun independently. On the right is a Blue Waterlily's inner sepal; 4 grow between the petals and the 4 outer sepals. The tile piece in the middle has 8 Heraldic Sun petals (stigmas) around its raised yellow sun. Circles and tear-shapes are Sun symbols, so this tile piece includes 10. Why make Heraldic Suns tear-shaped? One reason may have been because it is roughly the shape of a waterlily's stigmas (above), which represent Sunrays. The Heraldic Sun's shape was also probably influenced by a candle or oil lamp's flame. Two of the examples above are done in Four Colors (red dots), and 5 include gold, the Sun's color.

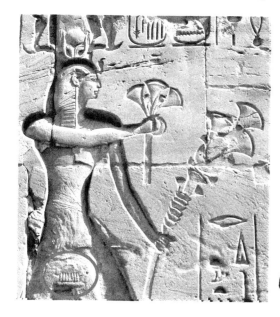

Heraldic Suns vs a Cobra-Row. a) The Pharaoh's sash includes 7 Heraldic Suns instead of **b)** the usual Cobra-Row. Both symbolized Sunrise/Ra and empowered and safeguarded the Pharaoh's seed. One of his titles was *"Horus, the first-born of Ra"* (CT, 1175). These Sun symbols protected Ra's unborn grandson, who as king would become his son (Horus).

a. b.

43

Heraldic Sun

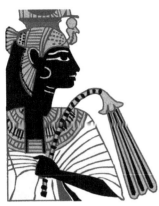
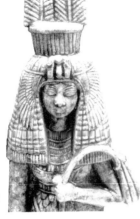

Heraldic Lily flails. These women each hold a long stemmed Heraldic Lily flail with 3 elongated Heraldic Suns. A limp flail may symbolize a woman's ability to be flexible, and accomplish things with a lighter touch. The king's crook and flail are made of rigid parts.

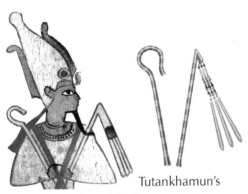

Tutankhamun's
Osiris' Crook and Flail

Threshing grain with flails.

a) Sa symbolizes protection.
b) Candle flame resembles inverted Heraldic Sun.

Osiris' Crook and Flail represent a herder and a farmer's tools, and symbolized kingship. The shepherd's crook signifies the Pharaoh's responsibility to care for his people. The flail, used for threshing grain to separate cereal from the chaff, symbolized the mourishment the Pharaoh and the Gods and Goddesses provided. Osiris' and Tutankhamun's flails each include 3 truncated Heraldic Sun shapes.

What inspired the glyph for gold? A White Waterlily bud and stem. **a**) After it has finished blooming, a Waterlily's stem sinks and lies flat on the bottom. The stem bends 90°, so the pod stays upright. That bend, which the stem *only* has when it's on the bottom developing seeds, is part of the gold glyph. **b**) Gold

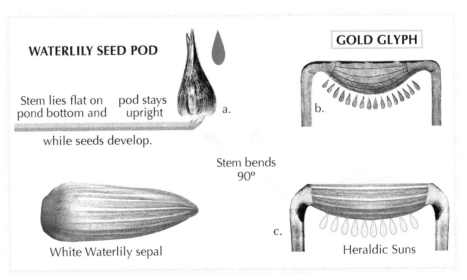

WATERLILY SEED POD

Stem lies flat on pond bottom and pod stays upright while seeds develop. a.

Stem bends 90°

White Waterlily sepal

GOLD GLYPH

b.

c.

Heraldic Suns

Heraldic Suns drip under the bud. **c**) The gold glyph combines 2 White Waterlily pods. With their sides sliced off, the 2 pods are joined to become a single sun/Sun filled basin dripping liquid gold Heraldic Suns. Some gold glyphs are bound near the 2 bends, probably to prevent loss.

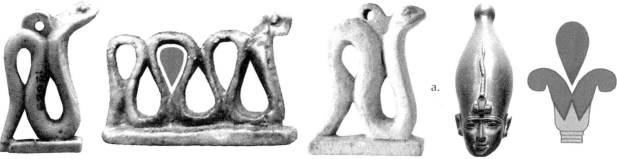

What was the connection between Heraldic Suns and cobras? In art, cobras were often made to form negative-space Heraldic Suns with their coils. It was another way of combining cobra and Sun, a relationship initially based on the Blue Waterlily. The 3 cobras, on the left, are in unnatural and unstable postures. **a)** When a cobra flares and threatens to strike, most of its body lies flat on the ground for balance and stability – these cobras have neither. Picturing them off-balance made them less able to strike and, therefore, less dangerous. The negative-space Heraldic Suns (Life) helped calm the cobra's dangerous nature (Death).

Another cobra and Sun connection. The royal Uraeus is modeled after the Egyptian Spitting Cobra, capable of accurately hitting targets up to 8 feet away. Its venom does not harm the skin, but can blind if not washed out of one's eyes immediately, which is not easy to do in the desert. A Uraeus reinforced the idea that it was dangerous to look at a Goddess, God, or any figure wearing a Uraeus. That, and staring at the Sun could both blind.

Neutralizing dangerous creatures. Snakes are often depicted being wounded to minimize their threat. This snake's coils form 3 Heraldic Suns, helping to weaken it. Often dangerous animals were depicted without legs so they couldn't give chase. Cats were especially valued because they helped rid areas of snakes, rodents, and large insects.

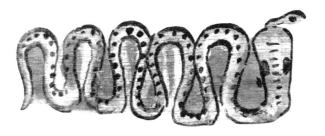

Egyptian cobra with 10 red Heraldic Suns in its coils, facing a bronze mongoose.

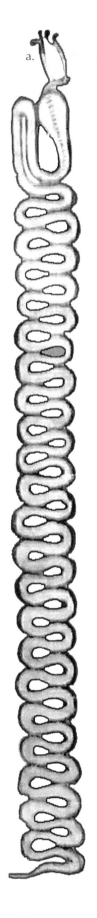

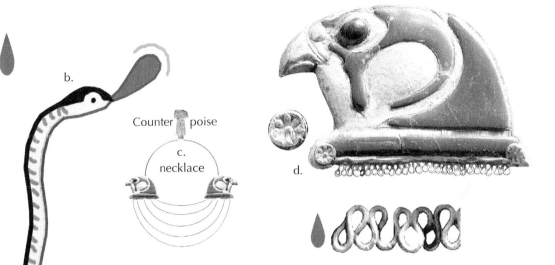

Counter poise

c. necklace

Heraldic Suns. a) A cobra, wearing an Atef Crown, creates a stack of 43 negative-space Heraldic Suns with its coils – resurrection symbolism. **b)** A Spitting Cobra standing on its tail, with a Heraldic Sun coming out its mouth = the poison the cobra sprays and staring at the Sun both blind. **c)** Necklace design. **d)** One side of the necklace was strung on the looped wire under this golden Horus head; the other side was strung under its mirror image. The wire's negative-space Heraldic Suns emphasize Horus' connection to the Sun, his father. Notice the similarity between Horus' looped wire and the first cobra's body (**a**). Just above both ends of the looped wire are Waterlily centers and suns. Horus was a sky god and the *"embodiment of divine kingship and protector of the reigning Pharaoh"* (**S**haw, **N**icholson, 133). During the Old Kingdom, he merged with the Sun to become Ra-Horakhty. **e)** Osiris, with a Resurrection Bud on his head, standing on a Spitting Cobra that's spraying red and blue tear-shaped droplets (Heraldic Suns) of poison on beheaded foreigners, their arms tied behind them. Osiris is often depicted with black or green skin, with an X drawn on him.

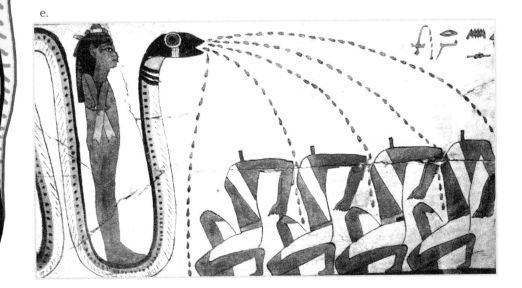

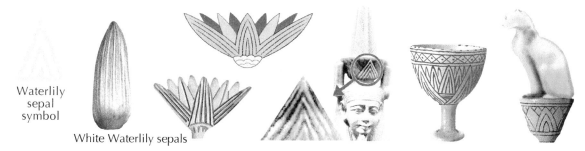

Waterlily sepal symbol

White Waterlily sepals

Waterlily sepals symbols on Waterlilies. Sepals are the 4 outer petals, usually green, that cover its bud. A White Waterlily's sepal has approximately 10 raised veins that converge at its tip; the papyrus sepal has only one. **a)** A White Waterlily sepal is 3 times as long as wide; a papyrus' sepal is roughly 12 to 1. Waterlily sepal symbols were frequently used in architecture, on columns in particular.

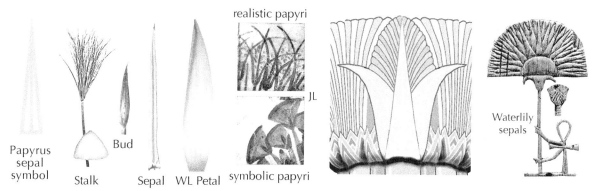

realistic papyri

JL

Papyrus sepal symbol

Stalk Bud Sepal WL Petal symbolic papyri

Waterlily sepals

Papyrus sepals symbols on papyri. A papyrus sepal is long and narrow, with a single raised spine down the center. Papyri live along the banks of the Nile and in water up to 1 foot deep. Waterlilies live in water from 1 to 5 feet deep. Both have thick horizontal rhizomes (roots), along which they sprout new stalks or stems, so they tend to cluster. Both plants also produce seeds. Waterlily petals have faint veins.

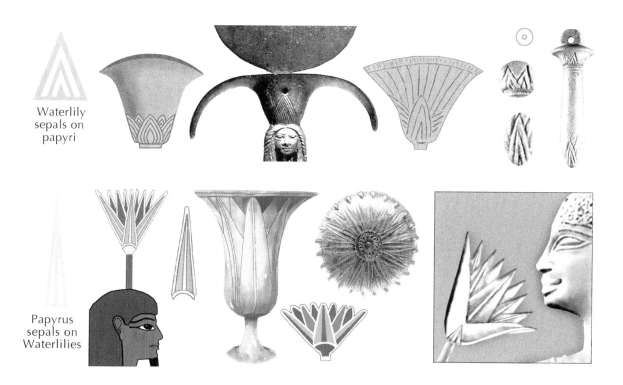

Waterlily sepals on papyri

Papyrus sepals on Waterlilies

Papyrus

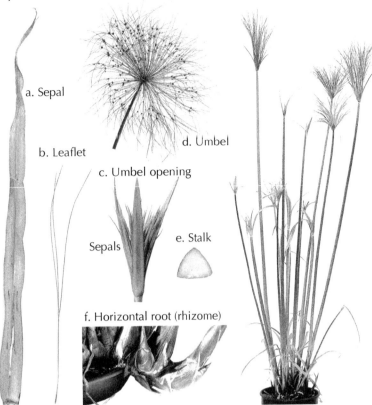

a. Sepal

b. Leaflet

c. Umbel opening

d. Umbel

Sepals

e. Stalk

f. Horizontal root (rhizome)

Papyri were an important source of Waterlily-related symbolism. a) Long, narrow sepal with raised spine. **b)** Leaflet. **c)** An opening umbel resembles a Blue Waterlily profile. **d)** Mature umbel. **e)** The stalk's triangular cross-section looks like a Waterlily sepal symbol with bulging sides (below). **f)** New stalks sprout along the root. Sheets of papyrus were made by layering slices of papyrus pith (white core) then pounding them together. The compressed layers were soaked in water for 5 days to remove the sugar, then pressed between 2 heavy pieces of absorbent material for another 6 days. The little sugar that remained in the papyrus acted as a binder and stabilizer.

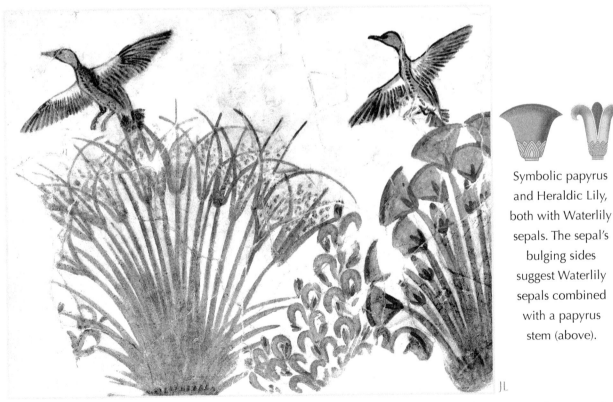

Symbolic papyrus and Heraldic Lily, both with Waterlily sepals. The sepal's bulging sides suggest Waterlily sepals combined with a papyrus stem (above).

There are both realistic and symbolic papyri in this Amarna painting, •1340. The papyrus cluster on the left is realistically depicted. The papyri on the right have stylized heads, each with a red band across the top, which usually indicates papyrus. They are papyri because they are growing *on* the bank.

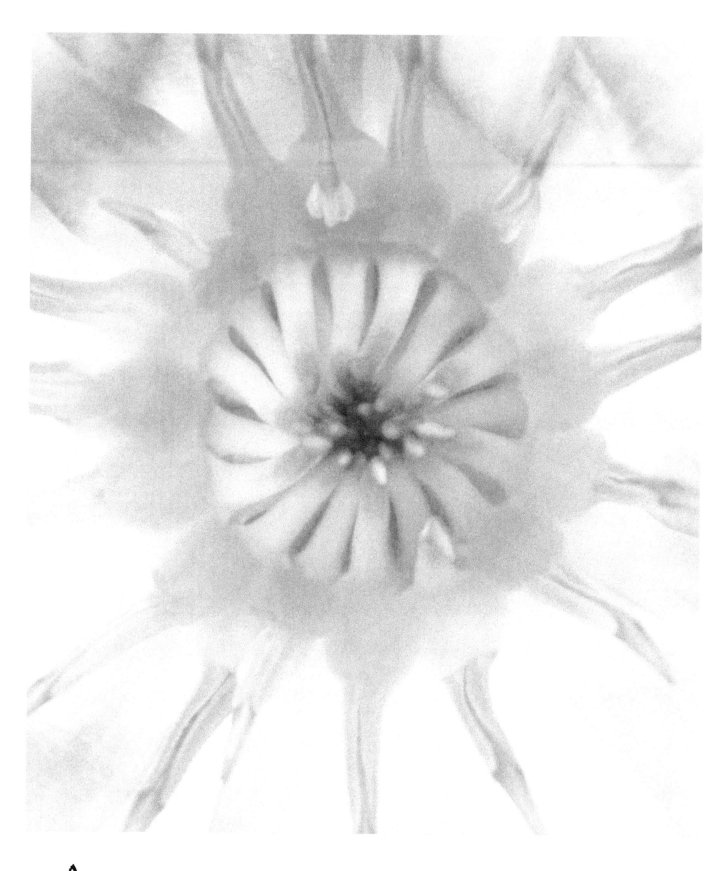

A god may be sensed and seen not only in his or her attributes of fragrance, radiance, and power but also and more forcefully in the way he or she affects a person's heart.

Erik **H**ornung (134)

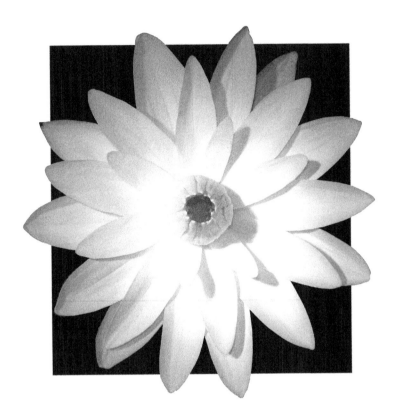

The experiential root of Egyptian religion is not safely located in the distance of a civilization long since past but belongs to the very structure of the human being as a religious being. In becoming receptive to it, we provide the soil in which it can begin to grow within ourselves and become part of our inner orientation toward the world of spirit.

Jeremy Naydler (2: 11)

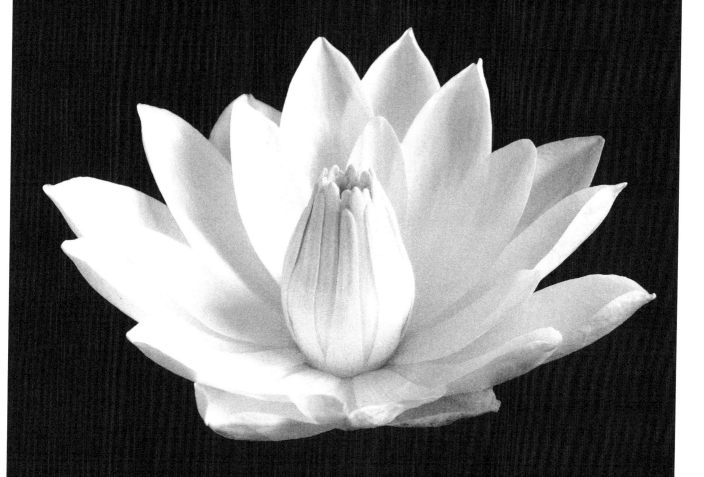

Part II

Ancient Egyptian Sacred White Waterlily

Anatomy, Habits, and Influence on Ancient Egyptian Symbolism

White Waterlily

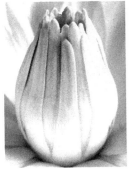 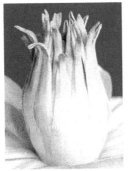 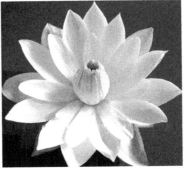 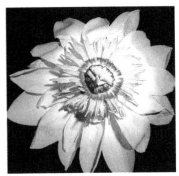

Stamen cluster Stamens flaring Top open Red Sun on stamens

The Sacred White Waterlily. The White Waterlily's stamens are flat and form a relatively smooth cluster. Their tips sometimes flare out if the stem is cut. Partially open tops allow insect pollinators in and the sun/ Sun inside to rise out. Red bands on the stamens' undersides form a circle (Sun).

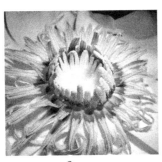 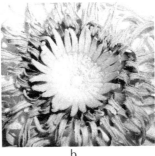 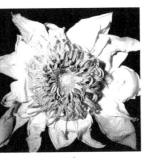

a. b. c.

A White Waterlily drying. a) Its styles stand upright, inside the red circle formed by the stamens. **b)** The styles are fully opened. **c)** As it dries, the White Waterlily's curling stamens can cause it to resemble a chrysanthemum. Its waxy sun has remained fairly intact, but the stigmatic basin around it has turned reddish.

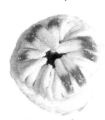 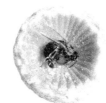

Long styles Dead in Solar Boat Stigmatic-basin Floral apex/sun

What inspired the myth of the dead riding in a Solar Boat? Both Blue and White Waterlilies' stigmatic basins are filled with fluid on their first day open. Some bees fall in, and pollen from other flowers washes off them into the fluid, fertilizing the waterlily. Some bees also drown, as this one did. "The Dead riding in a Solar Boat" is Egyptian mythology based on this commonly observed natural event. Bees were known as Tears of the Sun. When a bee is full, its enlarged abdomen has a golden glow, similar to a Waterlily's glowing sun. The White Waterlily's sun can appear to be glowing white-hot.

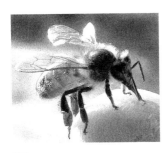 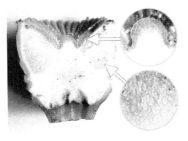 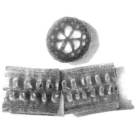

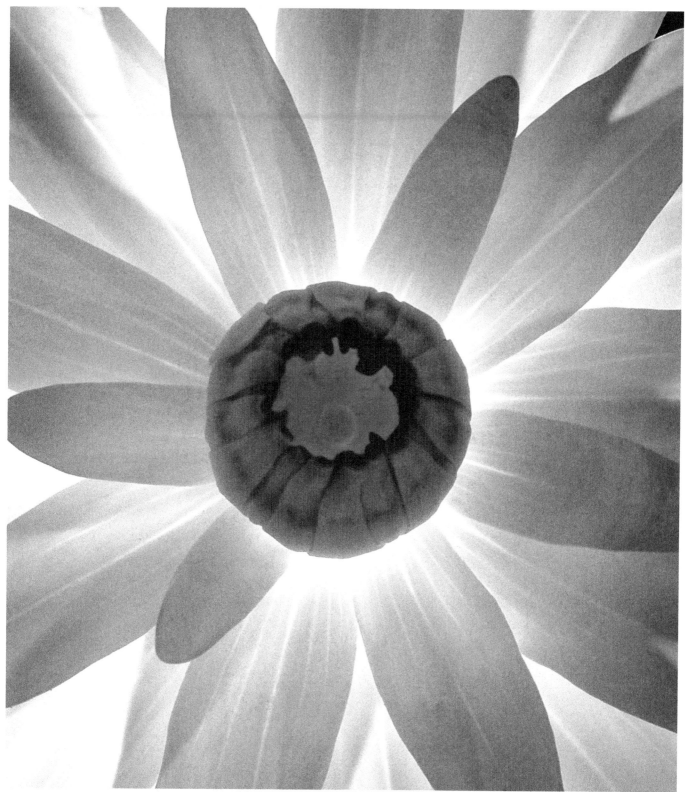

Sunset colors in a backlit White Waterlily, which opens shortly after Sunset.

Osiris does indeed seem to be absorbed into Ra, and becomes the night sun, which awakens the underworld dwellers from the sleep of death.

Erik Hornung (96)

Waterlilies Compared

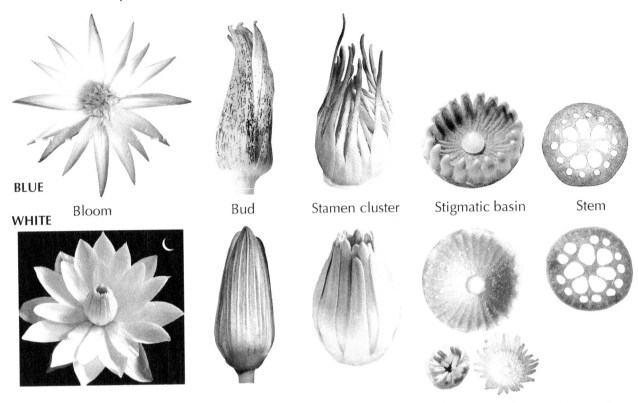

BLUE

Bloom Bud Stamen cluster Stigmatic basin Stem

WHITE

How do Blue and White Waterlilies compare? The Blue Waterlily's stigmatic basin is shown with its styles intact; the White Waterlily's styles and pollen were removed so its rays could be clearly seen. Part of the White Waterlily's mystique was that it bloomed at night. However, from 5–8 p.m. neither Waterlily was open, and that was when the Sun was at its most vulnerable, when the death-serpent Apophis attacked.

Blue Waterlily – Nymphaea caerulea

- Bloom: blue, white, pink or purple.
- Petals colored so flower appears to glow.
- Stamens start flat, become cylindrical.
- Loosely clustered stamens.
- The sun is translucent.
- Bloom has a subtle, beautiful aroma.
- Day 1 open: 10 a.m.– 2-3 p.m. (4-5 hours).
- Day 2-3 open: 10 a.m.– 4-5 p.m. (6-7 hours).
- Sun out and flower open only during the day.

White Waterlily – Nymphaea lotus

- Bloom: white, yellow, and a bit of red.
- Stamens are flat and smooth.
- Stamen cluster's top is often open.
- Golden Sunray-like stigma.
- The sun is cloudy and less translucent.
- Bloom has no discernable aroma.
- Petals are thicker and wider than Blue's.
- Open 8 p.m.– noon (16 hours) for 3 nights.
- Moon and flower visible day and night.

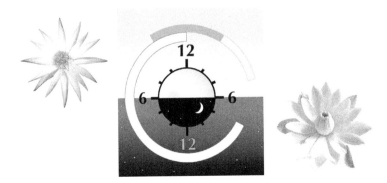

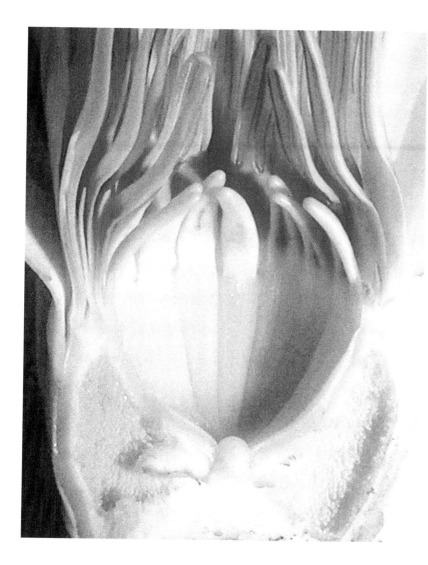

A White Waterlily's ovary just before it blooms is colored with Sunrise colors. **a**) The stigmatic basin, with its sloping sides, is usually filled with fluid at this point. The basin flattens out horizontally as the flower opens. **b**) Translucent, immature seeds fill the ovary, forming a dense collar around the sun in the middle. **c**) On its first day open the basin is filled with fluid and some bees fall in and drown.

a.

c.

b.

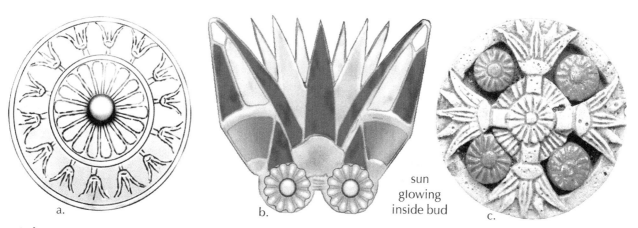

a.

b.

c.

sun
glowing
inside bud

Why were Blue and White Waterlily features combined in art? The White Waterlily's stigmas are smoother and more like Sun rays than the Blue's, so they are often added to a Blue Waterlily's depiction. **a**) Blue Waterlilies around a White Waterlily's stigmatic basin with a raised golden sun. **b**) Blue Waterlily with flanking buds, over 2 White Waterlily centers; done in Four Colors. **c**) Four gray Blue Waterlilies spaced between 4 blue centers, around a White Waterlily's stigmatic basin. Merging the two Waterlilies combined their individual symbolism. Together they were open for most of the day and night.

White Crown

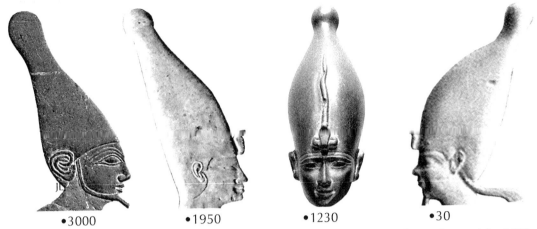

•3000 •1950 •1230 •30

What inspired the White Crown of Upper Egypt, and why did it remain virtually unchanged for 3000 years?

The earliest White Crown, pictured here, comes from Narmer's Palette, •3000 (ceremonial palette).

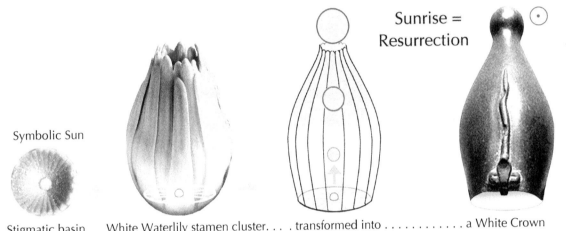

Sunrise =
Resurrection

Symbolic Sun

Stigmatic basin White Waterlily stamen cluster. . . . transformed into a White Crown

What does the White Crown resemble? The White Crown, less its top knob, resembles a White Waterlily's stamen cluster. If its sun were to rise and swell, as the Blue Waterlily's sun does daily in myth, then the top knob symbolizes the Sun. That is known to be true from the Atef Crown, which includes a White Crown with its top knob depicted as the Sun (opposite). **The White Crown is primarily a resurrection machine** (Sunrise). Crowns of Waterlily petals, stamens, or styles suggest the wearer's head is the Sun.

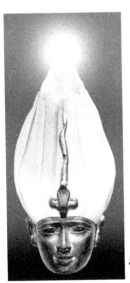

a.

A literal interpretation of a White Crown, showing its stamens and rising sun/Sun. White Crowns seldom include stamen lines. **b**) This piece is an exception from a time when there was a great influx of foreigners into Egypt, •600. Some symbols, both the Red and White Crowns, for instance, were often depicted in greater detail than previously, possibly to clarify the symbolism for people less familiar with it. A Waterlily, or any Sun symbol, can cover part of a Sun Disk.

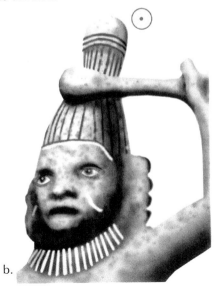

b.

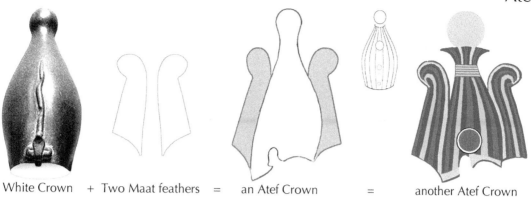

White Crown + Two Maat feathers = an Atef Crown = another Atef Crown

What inspired the Atef Crown? Adding Maat feathers to either side of a White Crown transforms it into an Atef Crown, also known as Osiris' Crown. The crown can be quite festive looking with add-ons that may include stripes, extra Sun(s), horns, and cobras (below). The sun in a Waterlily bud sits near its bottom. Therefore, when the king wears an Atef Crown, that sun would be inside his head, and it is known that *"Osiris had much suffering in his head from the heat of the Atef Crown"* (**C**lark, 137).

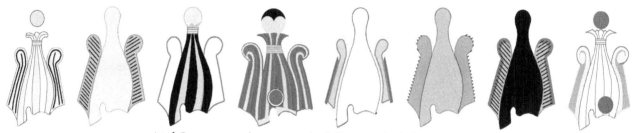

Atef Crowns are the most colorfully varied of all the crowns.

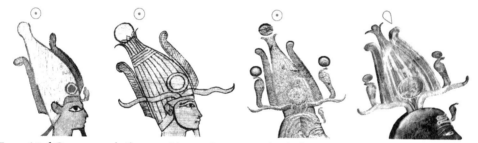

Four Atef Crown variations, with top Suns: attached, detaching, detached, and Heraldic.

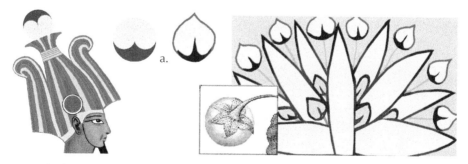

Why depict a Mandrake Sun on an Atef Crown? a) Osiris/Atef Crown's top Sun as a mandrake fruit – a dark wave across the Sun. *"Mandrake has now been proven to be both hallucinogenic and soporific"* (**M**anniche, 2: 102). It was used in love potions and medicine (ibid). Mandrake's color is the skin color of upper-class women in ancient Egyptian paintings. The Mandrake symbol (**a**) was designed to resemble a noble woman's breasts and bottom – Mandrake helped revive Osiris for his physical incarnation – the other was spiritual.

Binding

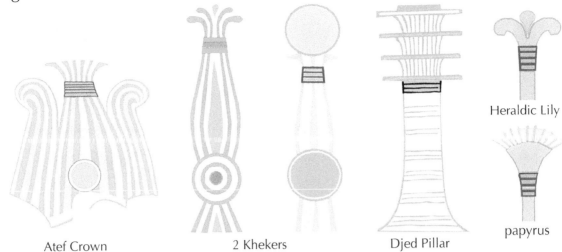

Atef Crown 2 Khekers Djed Pillar Heraldic Lily papyrus

Why are some symbols bound? Binding symbolically holds things together or blocks a passageway. It was used to protect and retain the potency of an object, by binding its throat, as in these cases. *"Knots are used as a barrier, which hostile forces cannot pass"* (**P**inch, 84), and *"The knot was closely connected with the magic of binding and releasing"* (**L**urker, 75).

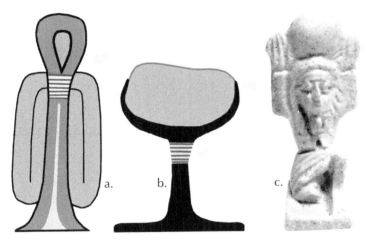

a. b. c.

The **a) Knot of Isis** symbolizes a woman's reproductive organs (page 78). It is bound below its uterus/Heraldic Sun, perhaps to stop bleeding or pregnancy. **b**) A headrest and pillow designed to keep one's head off the ground. Its binding may symbolize protection against nightmares: *"Evil filthy things which Seth, son of Nut, has made"* (*Papyrus Beatty*, te **V**elde, 112). The headrest has cleverly been shaped to resemble **c**) air god Shu with his arms raised, and indeed, Shu is sometimes depicted holding up the night sky – Sky Goddess Nut is his daughter. The tops of the Atef Crowns below are all bound, trapping Suns inside. They appear to be outside only because nothing is ever depicted covering a Sun Disk.

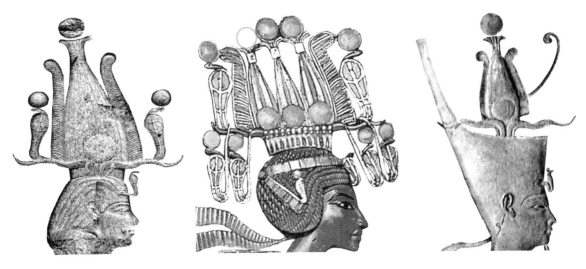

The Sacred Nile

To the Eyes of the Person of Imagination, Nature is Imagination itself.

William Blake (1757 –1827)

If you truly love Nature, you will find beauty everywhere.

Vincent Van Gogh (1853 –1890)

I've made an odd discovery. Every time I talk to a savant I feel quite sure that happiness is no longer a possibility. Yet when I talk with my gardener, I'm convinced of the opposite.

Bertrand Russel (1872 - 1970)

Kheker

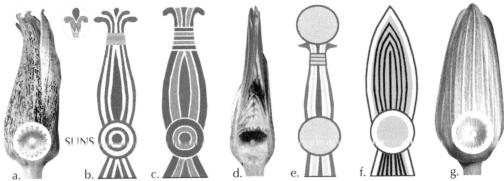

a. b. c. d. e. f. g.

What inspired Khekers? (b,c,e,f). **a**) A Kheker resembles a Blue Waterlily bud, with the bud's stigmatic basin and sun (Sun) centered on a disk over where the sun is located inside the bud. **b, c**) These both have Heraldic Lily tops, but the top of **c**'s Heraldic Sun was painted out (?). **d**) A Blue Waterlily bud split vertically, with its sun sitting at the bottom of the shaded basin. **e**) A Kheker with 2 large golden Suns. **f**) This Kheker resembles **g**) a White Waterlily bud with its stigmatic basin and sun on a white disk. The Kheker's purpose was to help enable and empower resurrection, and appears in both men's and women's tombs.

•1930 •1900 •1425 •1390 •1295 •1294 •1279 •1250 •1200 •1182 •1153 •1147 •1133 100•

Kheker variations. The earliest of these, •1930, is the most detailed, with its intact Heraldic Sun rising out its stylized Heraldic Lily top. Its lower Sun is inside 2 green circles that symbolize a Waterlily's stigmatic basin and stamens. Like cowry shells, Khekers symbolize female genetalia by resemblance.

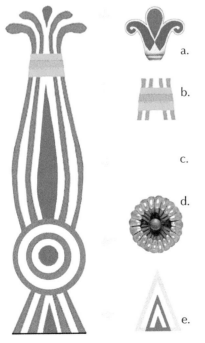

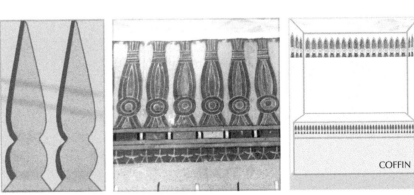

a.

b.

c.

d.

e.

COFFIN

As simple as Khekers may appear, they are actually complex distillations and arrangements of symbols. **a**) Heraldic Lily top. **b**) Binding. **c**) Vulva and Waterlily bud shape. **d**) The center of a White Waterlily as golden jewelry, •3000. **e**) The glyph "give" (dark blue), as in "give life." The tomb was envisioned as a womb from which the deceased would be reborn, and Khekers supplied essential female sexual symbolism.

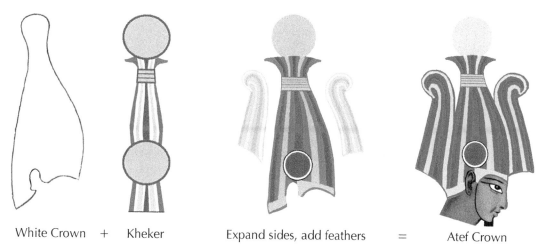

White Crown + Kheker Expand sides, add feathers = Atef Crown

A Kheker can be combined with a White Crown and feathers to make an Atef Crown. The Kheker's design may have been modified to serve as a symbolic crown. Its sides need to be expanded to fit the White Crown's wider shape, 2 Maat feathers (justice/sky) added, with optional horns and cobras. First came the White Crown, then the Kheker, and then the Atef Crown. All 3 are resurrection machines. These symbols had to connect with people on a deep and meaningful level to have endured as long as they did.

"Harmony was thought to be the greatest good to which people could aspire." Henri Frankfort (2: 29)

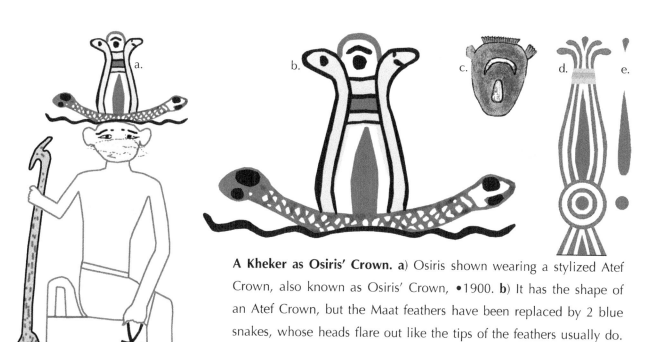

A Kheker as Osiris' Crown. a) Osiris shown wearing a stylized Atef Crown, also known as Osiris' Crown, •1900. **b)** It has the shape of an Atef Crown, but the Maat feathers have been replaced by 2 blue snakes, whose heads flare out like the tips of the feathers usually do. This Atef Crown's White Crown, instead of having many stamen bands, has a simpler Kheker's interior. The top of the crown, usually a rising Sun, has become **c)** a mournful heart, terrified it may weigh too much to resurrect. At the crown's base is a horizontal 2-headed phallic serpent over a wavy line that suggests Khnum's horns, a cobra, and water. One of the most unusual aspects of this painting is that the figure is full face, instead of the usual profile. It is a daring and imaginative image. **d)** A Kheker, •1930, contemporary with the crown (**b**). **e)** It includes 3 red Suns, 2 Heraldic and 1 Sun Disk.

Resurrection Bud

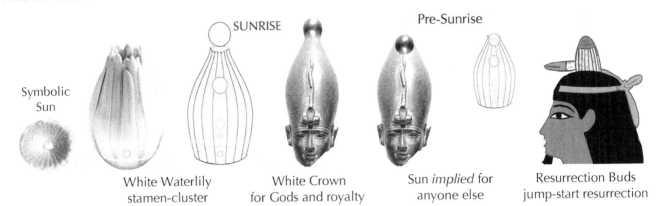

Symbolic Sun

SUNRISE

White Waterlily stamen-cluster

White Crown for Gods and royalty

Pre-Sunrise

Sun *implied* for anyone else

Resurrection Buds jump-start resurrection

What inspired Resurrection Buds? Most of them resemble a White Waterlily stamen cluster, which was the inspiration for the White Crown. A White Crown seldom has its stamen lines showing, whereas a Resurrection Bud frequently does (below). Usually, only non-royals are depicted with Resurrection Buds. It's a commoner's White Crown, but with the Sun implied and not showing. As the central part of a White Waterlily, a Resurrection Bud was understood to have a sun/Sun inside. It represents the moment just before Sunrise/resurrection. The term **Resurrection Bud** replaces "~~incense-cone~~" (opposite).

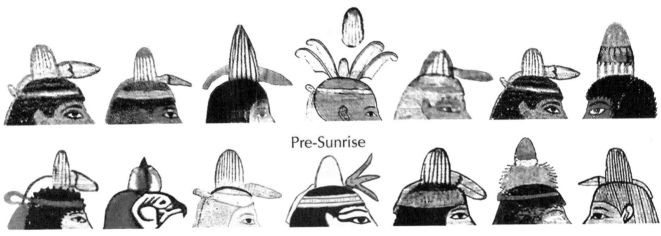

Pre-Sunrise

Resurrection Buds vary widely. Each of these includes a few common elements arranged in different combinations. Eleven of them have stamen lines; 4 have red tops; 10 include a Blue Waterlily bud or bloom, and 1 incorporates a nest. Ten of the figures wear headbands. The red tops don't represent Sun Disks because those aren't depicted over non-royals, therefore, they are intentionally egg-shaped. There is also a "sun" inside an egg, and it's also a birth symbol. Resurrection Buds imply the White Waterlily's sun is about to rise and the deceased's resurrection begin. Artists and priests tested the limits of what was permitted, because eternal lives were at stake, and they had loved ones, or could be bribed.

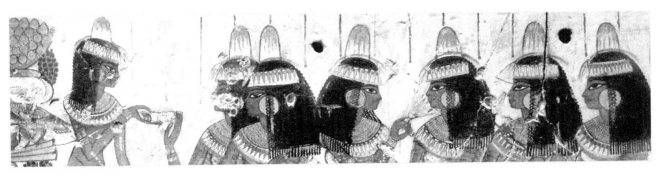

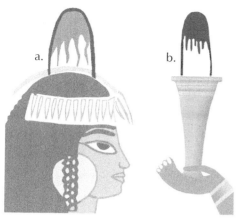

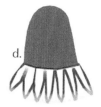

Why do some Resurrection Buds resemble incense-cones?
a) Resurrection Buds were sometimes made to resemble
b) incense-cones to symbolically give them scent, which
White Waterlilies lack – it didn't mean they had a symbolic
wad of scented, congealed fat on their head (which only
releases its scent when burned). This figurine has a "symbolically fragrant" White Waterlily stamen cluster
on her head. Beautiful aromas indicated the presence of Goddesses and Gods, some of whom were an
essential part of resurrection. **c**) White Waterlily petals made to resemble incense-cones to give them scent.
d) The dark zig-zag petal-line resembles a water glyph. People wanted their Resurrection Buds to suggest the
Sun as much as possible, and to attract the Gods and Goddesses with its divine aroma.

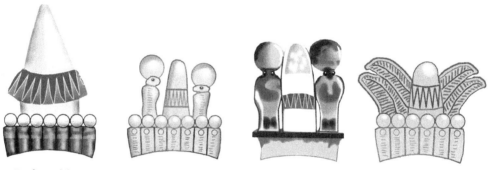

Resurrection Buds seldom appear on royalty. Ankhesenamun, Tutankhamun's Queen, •1330, is an
exception. These crowns of hers each includes a Resurrection Bud and a Cobra-Ring, both Waterlily-inspired
resurrection symbols used to empower resurrection.

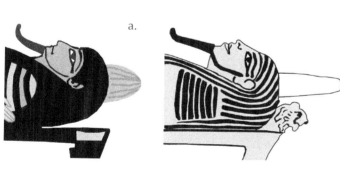
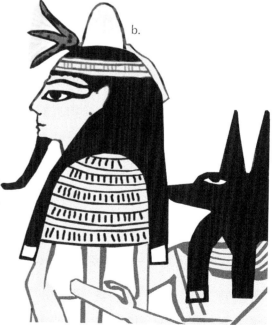

Impossible. a) The Resurrection Buds on these sarcophagi are
not incense-cones. They are symbols intended to empower
resurrection. **b**) A Resurrection Bud, colored realistically like
a White Waterlily. A priest in an Anubis mask steadies the
sarcophagus from behind, temporarily becoming Anubis by
resemblance.

Resurrection Bud

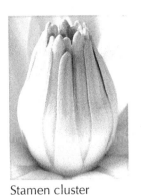

Stamen cluster

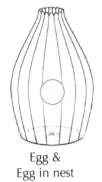

Egg &
Egg in nest

Sunrise

Egg in nest

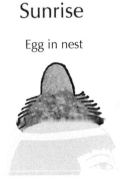

Egg &
Egg in nest

Egg &
Egg in nest

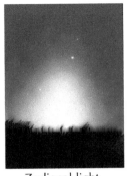

Zodiacal light

*"Oh Ra who are in your **Egg**, shining in your disk, rising in your horizon, swimming in your firmament, having no equal among the Gods."* (GL, 17)

White Waterlily stamen clusters, Resurrection Buds, and Zodiacal Light were all metaphors for Sunrise, which was a metaphor for resurrection. Egyptians likened the Sun to an egg because of the Sun's resemblance to its yoke. A White Waterlily's stamen cluster even resembles an egg with a tiny sun/yoke inside. On particularly clear, dry, dark, moonless nights in the desert, ~90 minutes before dawn, a subtle dome of light (half egg-shaped), now known as Zodiacal Light, can sometimes be seen on the eastern horizon. It is caused by light reflecting off a vast lens-shaped dust cloud slowly circling the Sun. Zodiacal Light fades as dawn approaches and is no longer visible when the Sun rises from 'inside' the 'egg' an hour and a half later. Post-Sunset, western horizon occurrences of Zodiacal Light are rarer. Palm trees on the horizon can give Zodiacal Light an egg-in-nest appearance, strengthening its connection to an egg. *"The cosmic egg was laid by Amun in his goose form or perhaps by Thoth in ibis form. The creator Sun god was hatched from this egg"* (**P**inch, 23). It may have seemed to Egyptians that they were getting a glimpse of the armature lying just below the surface of nature.

Pain relief? Some Resurrection Buds have a pair of large spots on them resembling the 2 spots on ancient Egyptian depictions of opium poppies. The spots on these Resurrection Buds may represent these women's desires for pain-free afterlives.

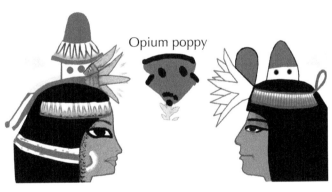

Opium poppy

"I am on high on the Waterlilies" (CT, 515).

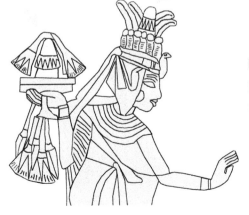

Royal Resurrection Buds. Queen Ankhesenamun stands in front of Pharaoh Tutankhamun (not shown). She balances a tray holding a Resurrection Bud with a Blue Waterlily petal collar. Draped over it are Waterlily blooms. She appears to be bringing a Resurrection Bud to the king, which suggests she may have been able to assist in his resurrection.

Red Crown

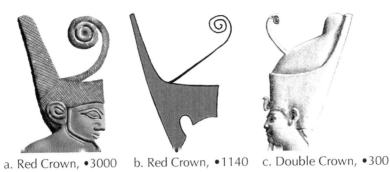

a. Red Crown, •3000 b. Red Crown, •1140 c. Double Crown, •300

What inspired the Red Crown, which remained virtually unchanged for 3000 years? a) The Red Crown, usually a king's crown, with its tall tapering back, fit snugly around the his ears, completely covering his sacred scalp. **b)** From the intersection of the cap and back, a line uncurls forward and up at a 45° angle, with the uncurled portion forming a coil or knot at the end. **c)** There are many Red Crown variations, but the commonest is the Double Crown, which combines the Red and White Crowns. Most crowns seem to have been purely symbolic, found only in artworks and texts. In ancient Egypt, a symbol pictured over someone's head made it easier to identify them, and in many cases helped empower her or his resurrection.

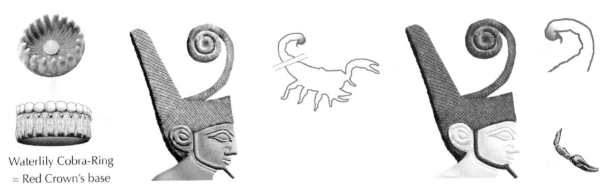

Waterlily Cobra-Ring
= Red Crown's base

The Red Crown's design is linked to the relevant symbols it resembles. One is a Waterlily's Cobra-Ring (page 34) with one cobra rearing above the rest. Another is a stylized scorpion. The base corresponds to the scorpion's body, the upright to its tail, and the king's beard to the scorpion's pincers. The curl suggests the uncoiling of its deadly tail. The Red Crown was not the only scorpion crown; another was Goddess Selket's. Her job was to help protect the Pharaoh's mummified body and organs, so a huge realistic scorpion on her head was appropriate. The Red Crown is not as realistically depicted because the king had a far greater range of functions to perform than Selket did, and terrifying people was not always appropriate.

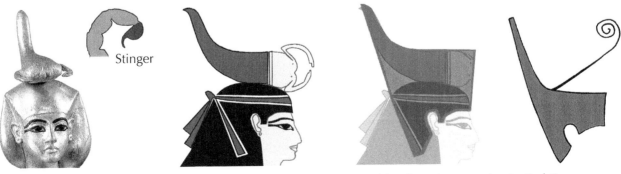

Stinger

Two Selkets, each with a stinger-less scorpion. It's an easy transition from her scorpion to Red Crown.

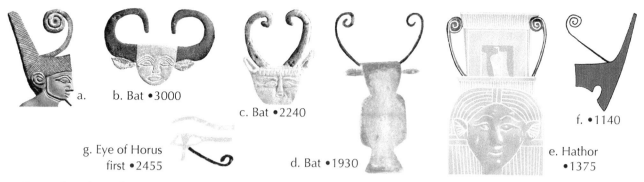

a. b. Bat •3000 c. Bat •2240 d. Bat •1930 e. Hathor •1375 f. •1140 g. Eye of Horus first •2455

Bat and Hathor's horns evolved to become identical to the Red Crown's curl. They are similar on Narmer's Palette, in that they both curl, but they are also very different (**a–b**). Narmer's **a**) Red Crown from his Palette. **b**) Bat from Narmer's Palette. **b–e**) Bat evolves into Hathor, and her horns become increasingly stylized. **e**) Part of a Hathor sistrum/rattle. The Red Crown includes a woman-warrior aspect because its curl, in part, symbolizes Hathor's horns, and her other persona is ferocious lioness Sekhmet. **f**) A Red Crown's curl is a stylized horn and polite warning. **g**) The Eye of Horus, which has an identical curl, first appeared about •2455 (discussed later). A scorpion's tail, a cobra, Hathor's horns, and the Red Crown's curl resemble one another in that they all curl and are potentially deadly.

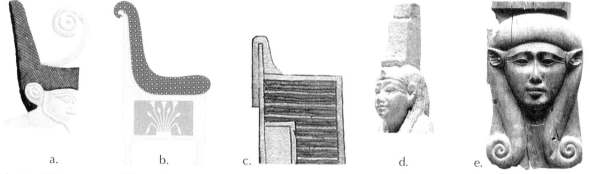

a. b. c. d. e.

The Red Crown resembles a throne. a) Narmer's throne-like Red Crown, •3000. **b**) Drawing of an Egyptian throne/chair, •1370. **c**) A throne with thick material draped over its back. Since, on one level, the Red Crown's back symbolizes a cobra/scorpion's tail, when the cloth covers it, any threat to the person sitting in the throne is reduced. The throne's base is the glyph for "enclosure" – it's done in Four Colors and resembles a plowed field. **d**) Isis with a throne on her head. **e**) Hathor's hair is curled to remind one of her horns.

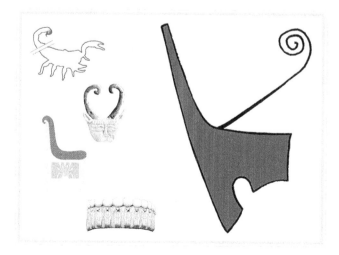

The 5 major influences on the Red Crown's design were: <u>scorpion</u>, <u>horn</u>, <u>throne</u>, the color <u>red</u>, and a Blue Waterlily's stigmatic basin or <u>Cobra-Ring</u>. Each of them is a powerful symbol on its own. The Crown's red color links it to Seth, blood, and is a warning color in nature. Conversely, red, when used with the Waterlilies, or as part of the Four Colors, symbolizes a White Waterlily. The Red Crown includes many red associations.

Double Crown

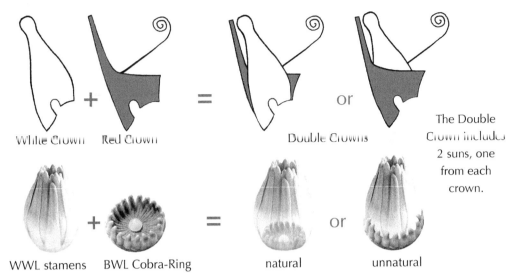

White Crown Red Crown Double Crowns

The Double Crown includes 2 suns, one from each crown.

WWL stamens BWL Cobra-Ring natural unnatural

Which is the correct way to unite the White and Red Crowns to make a Double Crown? They can be combined in 2 different ways, with either one on top. The White Crown was inspired by a White Waterlily's stamen cluster, and the Red Crown, in part, by a Blue Waterlily's stigmatic basin. Therefore, the Double Crown, which symbolized the unification of Upper and Lower Egypt, also united a part from each Waterlily, and each part included a sun. The Waterlily is in natural order when the stamens are outside the stigmatic basin. In the "unnatural" example above, the opposite is true, which is a reason for not putting the White Crown inside the Red. That arrangement would, however, place a ring of protective cobras, resembling a fortress wall, around the White Crown. And, the White Crown looks aesthetically more pleasing inside the Red Crown. But most importantly, it is possible to sculpt in 3 dimensions as a *single* wearable crown (below: **a, c, e**), while the other arrangement, White over Red (below: **b, d**) is not – they appear to sit side-by-side, with most of the Red Crown blocked from view.

> *"The notion of most fundamental importance is that relations between things,
> rather than the things themselves, are to be expressed as divine."* Stephen **Q**uirke (2: 48)

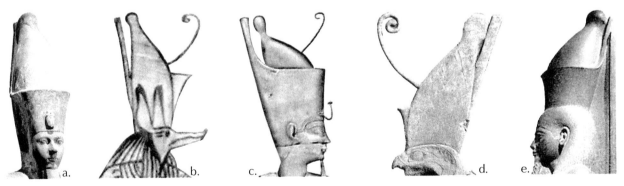

a. b. c. d. e.

These are examples of the 2 ways the Double Crown is commonly portrayed. When sculpted, the White Crown always goes inside the Red because the Red Crown won't fit inside the White without first shrinking dramatically. In the case of paintings, drawings, and shallow carving, either crown can go over the other. **c)** This Red Crown has grown so large that it appears to be swallowing the White Crown. Egyptian artists often used size to express relative importance.

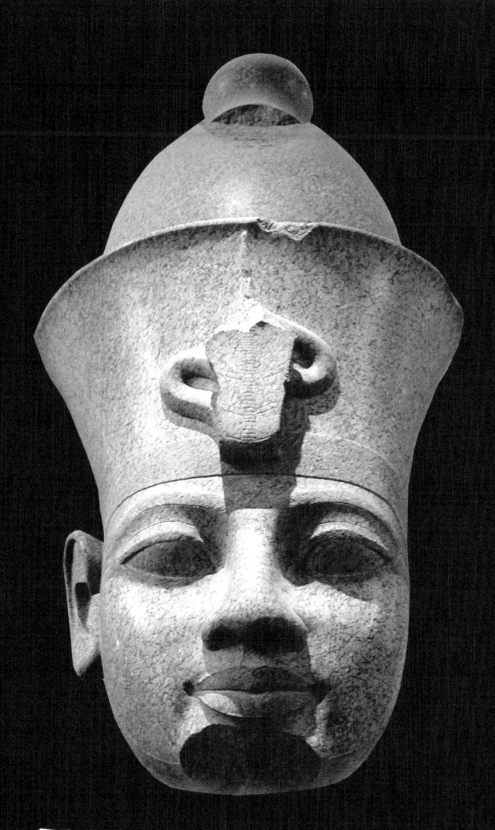

The ancient Egyptians felt themselves surrounded, and comforted, by the spirits of their ancestors living among them.

James P. Allen (2: 95)

Seshed's Crown

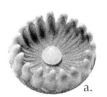 a. 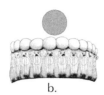 b. c. d. e. side view of d.

What was the inspiration for Seshed's Crown? It's one of the stylizations of the Cobra-Ring Crown, which was inspired by a) a Blue Waterlily's stigmatic basin. **b)** A Cobra-Ring Crown implies a Sun about to rise. **c)** A Sun Disk encircled by 1 or more cobras is a Cobra-Ring, •900. **d)** A princess' gold crown/diadem/circlet with Uraeus and Two Feathers – its top view resembles **c**. A circle with a dot in the middle symbolizes a Waterlily's center, a woman's breast, and the glyph for Sun. **e)** The Sun is implied by the Cobra-Ring, •1820. This Seshed's Crown includes stylized Waterlily centers spaced around its perimeter.

Seshed's Crown, "ssd," is another stylized Cobra-Ring Crown and is, therefore, a resurrection machine. The earliest known example of Seshed's Crown comes from the time just after Imhotep, •2600. It is a gold headband that supports a cobra in front, and 2 feathers behind. Initially, this Crown was combined with an Atef Crown, then with an Amun Crown. Seshed's Crown has one of its cobras rising higher than the others, as with the Red Crown (its back). The implication is that the person's head is the Sun. Several of these crowns are the only crowns to have ever been found. The most important associations a symbol could have was with the Sun and the 2 Waterlilies.

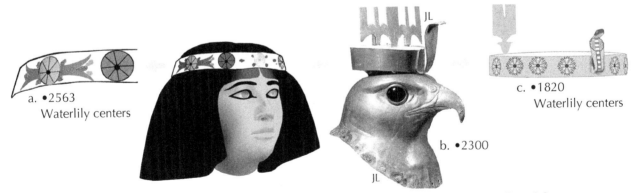

a. •2563
Waterlily centers

b. •2300

c. •1820
Waterlily centers

Cobra-Ring Circlet. a) This woman is wearing an early Waterlily-themed circlet or headband. **b)** Horus as a falcon, wearing a gold Circlet/Cobra-Ring with Two Feathers and a Uraeus. **c)** The Princess' diadem/Circlet/ crown is a gold band, also with a Uraeus in front and Two Feathers behind. The first Cobra-Ring with clearly defined cobras did not appear until •1360. *"The decoration of the modius (support for the double feather crown) with a ring of uraei seems to occur first in the reign of Amenhotep III, i.e. with images of Queen Tiye"* (Neal Spencer, British Museum, correspondence, 10/08). Nonetheless, the association of headband to Waterlily center, including its styles and sun (Cobra-Ring), is evident from at least this •2563 example, more than 1000 years earlier.

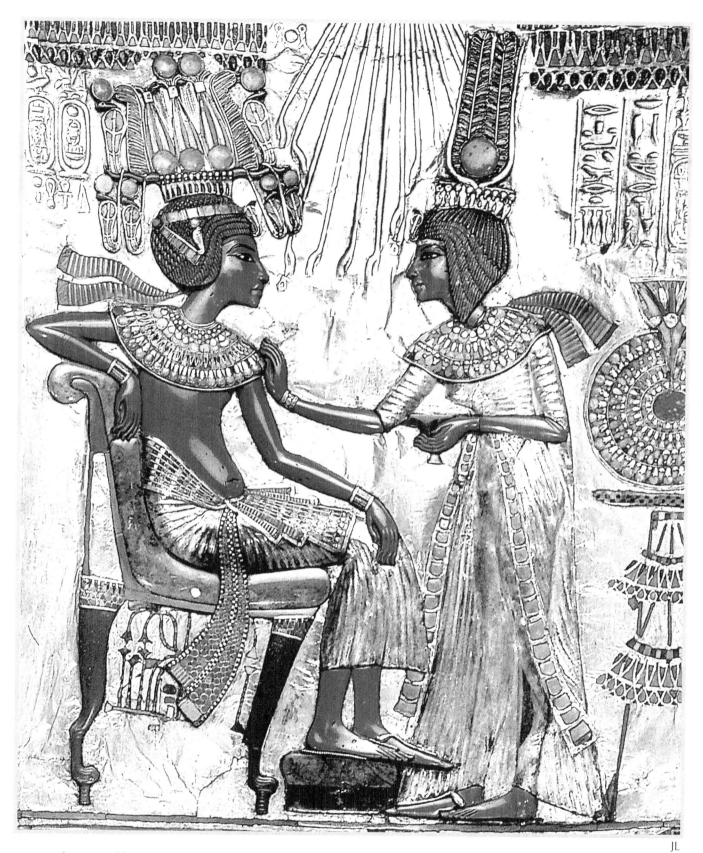

JL

King Tutankhamun and Queen Ankhesenamun, •1330 wearing Waterlily based crowns. Her's resembles
Seshed's Crown. It is a golden Cobra-Ring and rising Sun; a Uraeus in front and Two Feathers behind. To
that were added Hathor's horns. Other Waterlily symbolism is included in this image, some of it in Four
Colors. Tutankhamun has been given 2 left hands. Intentional? Her hands are correct. Photo by Jürgen Liepe.

Nemes Crown

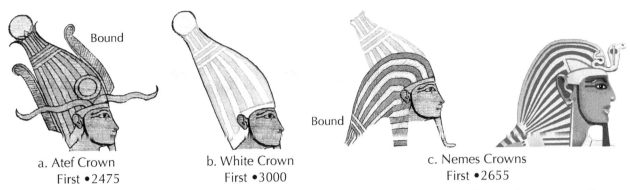

a. Atef Crown
First •2475

b. White Crown
First •3000

c. Nemes Crowns
First •2655

What inspired the Nemes Crown? a) An Atef Crown includes a White Crown, often with its stamen lines showing. Those lines seldom appear on stand-alone White Crowns. **b)** If a White Crown with its stamen lines showing is **c)** bent over backward, its end bound, with 2 flaps added in front and no visible Sun, it is a Nemes Crown. The sun in a Waterlily bud sits near the bottom of the bud on a yellow disk. Therefore, when the king is depicted wearing an Atef Crown, that sun would be inside his head. That the Nemes Crown is not known for overheating, which the Atef Crown is (page 57) suggests there isn't a Sun inside the Nemes Crown. However, its gold bands do symbolize Waterlily stigma and stamens as Sunrays radiating from his face, and its blue bands symbolizing the sky.

The Nemes Crown is shown being worn primarily by Pharaohs. It is related in appearance to both the Kheker and Atef Crown, and seems to have been refined into its final form before •2655 (above). The Coffin Texts recount how Horus gave one to his father Osiris to help him resurrect back into the physical world – Osiris also resurrects into the spiritual world as God of the Dead.

In addition to the Blue Waterlily, the Red Sea Pectin, or scallop (opposite), also influenced the Nemes Crown's design. There is a close resemblance, and sea shells from the Red Sea, where this shell is from, were thought by ancient Egyptians to have magical power (page 74) – the Blue Crown's design was also infuenced by a sea shell. The Nemes Crown is unusual in that it might comfortably be worn.

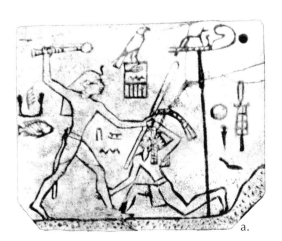

a.

a) The 2 headdresses on this Ivory label, King Den, •3000, resemble Nemes Crowns, except the one on the left is missing the 2 front lappets, and neither is gathered and bound behind, both important features of later Nemes Crowns. **b)** This kilt includes Sun rays like those on the back of the Nemes Crown. Notice the 5 Heraldic Suns.

b.

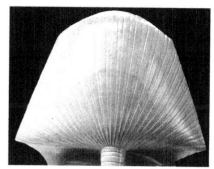

Red Sea Pecten (scallop) Nemes Crown back Nemes Crown back

The Nemes Crown back resembles a Red Sea Pectin's shell. In addition to their nearly identical shapes, with the same downward tapering and merging of their bands, these 3 examples each has approximately the same number of bands. The Red Sea Pectin is distinctive; both halves of its shell cup in the same direction, minimizing the habitable space inside. It lives in *"the Gulf of Suez and Great Bitter Lake"* notes M. Rusmore-Willaume in *Seashells of the Egyptian Red Sea*. The Nemes Crown's back looks like this when the bands are gathered and bound at the bottom – assuring that none of the king's sacred hair falls into the wrong hands.

E*ach image [of a god] was viewed as a means by which the god could interact with people.*

James P. Allen (2: 55)

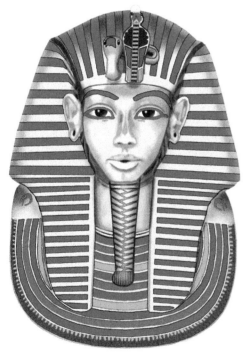
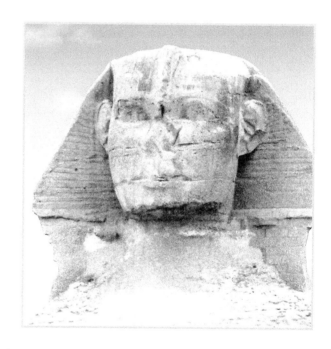

Tutankhamun's golden funerary mask shows him wearing a Nemes Crown, and the Sphinx famously wears one. Many cultures broke the noses off statues to suffocate them. That appears to be what was done to the Sphinx, as well, because Egyptians believed statues could come to life and potentially wreak havoc. Recent research suggests the Sphinx was built by Khufu's son Djedefre to honor his father, builder of the Great Pyramid. The Great Pyramid, hidden behind the Sphinx in this photograph, is 4600 years old, and it is said, "All things fear Time, but Time fears the Great Pyramid."

Blue Crown

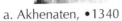
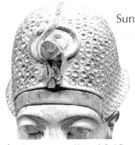
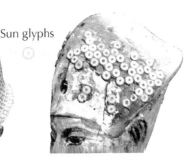

Sun glyphs

a. Akhenaten, •1340 b. Rameses II, •1240 c. Rameses II, •1240

What was the Blue Crown's inspiration? The Crown is depicted in 2 primary ways: **a**) as smooth and blue, and **b**) covered with Sun Disks. **c**) This Blue Crown is covered with blue faience disks, each with a hole in the middle, forming Sun glyphs. The Crown's color links it to the Blue Waterlily, a resurrection symbol. The holes in the front of crowns (**a**, **c**) are for mounting cobras, whose coils often form a Cobra-Ring (**b**).

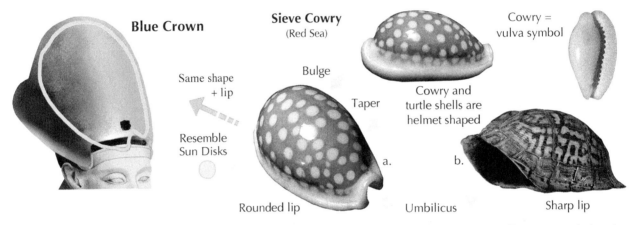

Blue Crown **Sieve Cowry** (Red Sea) Cowry = vulva symbol

Same shape + lip

Bulge

Taper

Cowry and turtle shells are helmet shaped

Resemble Sun Disks

Rounded lip Umbilicus Sharp lip

a. b.

The Blue Crown's inspiration a) was probably a Sieve Cowry from the Red Sea. Its shell is extremely hard and covered with white spots that resemble the Sun Disks found on many Blue Crowns. *"Heka [magical power] was thought to reside in rare or strange objects. Shells from the Red Sea came into this category and were used as amulets as early as the fourth millennium B.C."* (**P**inch, 107). **b**) A turtle's shell is even more helmet shaped, but in certain contexts *"the turtle was considered sinister and unclean"* (**P**inch, 42). However, some Blue Crowns have lips that can resemble a turtle's, suggesting a connection. The bottom of the Cowry Shell is a vulva symbol, ideally making the Crown's wearer hard to kill because he would be in a perpetual state of being born. The Blue Crown, cowry shell, and turtle shell are all examples of armor. The Blue Crown would have been awkward to wear, offering little if any protection. It was a symbolic war crown, and Rameses II is often shown wearing one in battle.

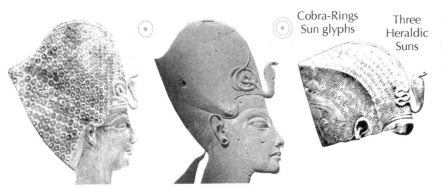

Cobra-Rings Sun glyphs Three Heraldic Suns

The Blue Crown's Uraeus is sometimes coiled to form a Cobra-Ring or Sun glyph. The Uraeus on the right forms 3 negative Heraldic Suns with its coils. The other 2 also form Sun symbols with their coils.

We come spinning out of nothingness,
scattering the stars like dust.

NASA stars, ancient Egyptian stairs

Rumi (1207–1273)

Seshat's Crown

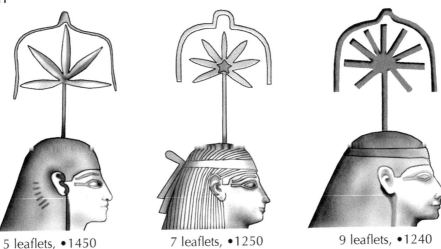

5 leaflets, •1450 7 leaflets, •1250 9 leaflets, •1240

What are the elements in Seshat's Crown? Seshat, Goddess of wisdom, knowledge, writing, architecture and measurement, is usually depicted wearing a strange crown featuring a 5, 7, or 9-pointed symbol under an arching line with a pronounced hump in the middle. The arched symbol is neither a bow nor a crescent moon, as has commonly been suggested, because neither has that hump in the middle.

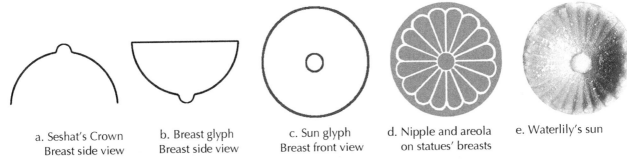

a. Seshat's Crown b. Breast glyph c. Sun glyph d. Nipple and areola e. Waterlily's sun
Breast side view Breast side view Breast front view on statues' breasts

What is the arched line in Seshat's Crown? a) The crown's top resembles an inverted **b)** hieroglyph for breast, the front view of which is **c)** the hieroglyph for Sun, a breast and a Waterlily's center (stigmatic basin). **d)** A Waterlily's center as nipple and areola, from a statue of MeritAmun. A woman's milk-producing lobules swell when she is pregnant, encircling her nipples inside her breast like these stigmas encircle their sun (crocodiles nurse on stigma, page 27). **e)** A White Waterlily's stigmatic basin and sun.

Goddess Seshat's Crown also includes a marijuana leaf with 5, 7, or 9 leaflets. Marijuana had a long history of medicinal and rope making use in ancient Egypt. Her duties included laying out ground plans for temples in a ceremony called "Stretching the Cord." She may have used rope made of hemp, which is mentioned in the *Pyramid Texts* (**M**anniche, 1: 82). More

5 leaflets 7 leaflets 9 leaflets

is not known about marijuana use in ancient Egypt is because, *"the ancient Egyptian word 'smsmt' was in the past wrongly taken to mean sesame but has now been shown to be Cannabis Sativa* (marijuana)" (**M**anniche, 1: 147). Cannabis pollen was found on Rameses II's mummy (ibid, 82). Marijuana can be effective for pain and nausea relief. Many people online recognized the leaf.

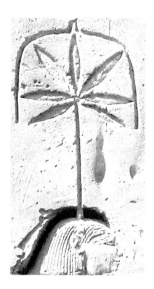 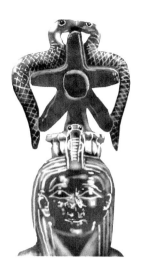 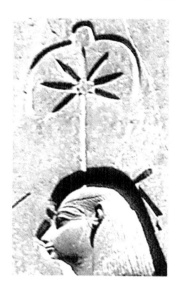

Goddess Seshat's Crowns. The center example is an imaginative variation, •500. The breast symbol has been replaced with a pair of cobras, and the leaf with a 5-pointed star that rises out of a Cobra-Ring. The Crowns on either side of it are typical representations. In her role as Goddess of Measurement, *"Temple reliefs of the Old and Middle Kingdoms show her in the act of recording the quantities of foreign captives and booty in the aftermath of military campaigns"* (**S**haw/**N**icholson, 264). She was shown as a *"woman often wearing a leopard skin* [worn by high priests] *over her robe"* (**W**ilkinson, 3: 166). Depicting things in front of a Sun Disk was avoided, so the leaf is cleverly shown under the breast symbol, which is another Sun symbol. Seshat's Crown symbolizes a woman's breast, a nurturing Sun symbol, over a marijuana leaf, which thrives in full Sun.

> *"Take care of people...they are his [god's] likeness that came from his body."*
>
> A Pharaoh's instructions to his successor. James P. Allen (2: 57)

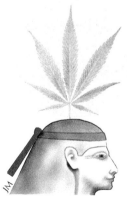

\mathcal{S}ymbols are not confined to time and place, but to a large extent follow certain rules independent of ethnic tradition and religion. Psychologists have established that images do not only approach...people from the visible world but also exist in the depths of...each soul, the unconscious. Archetypes enter the conscious mind in the form of symbols and myths... Archetypes exist in the souls of all people.
 Manfred Lurker (10)

Isis Knot

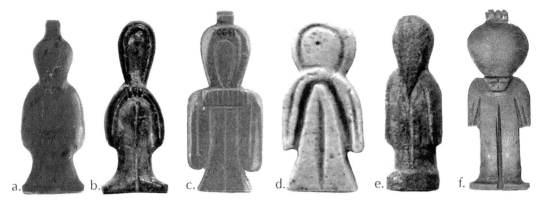

What inspired the Isis Knot? They look anthropomorphic, with Heraldic Sun heads, arms at their sides, and legs and feet indicated. These examples vary from **a**) one without internal details to **f**) one with an unusual face. The blue one **d**) lacks a Heraldic Sun head, and thereby loses that powerful symbolism. The pieces are made of: **a, c, e**) red jasper, **b**) dark steatite, **d**) blue faience and **f**) brown slate.

Woman's reproductive organs

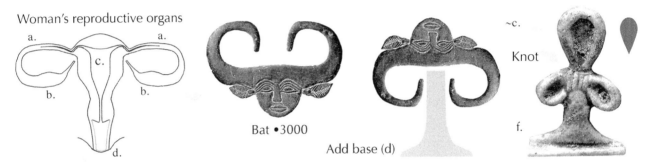

Bat •3000

Add base (d)

~c.

Knot

f.

e.

The Isis Knot, or "Blood of Isis," resembles a woman's reproductive organs, •3000. **a**) Fallopian tubes. **b**) Ovaries. **c**) Uterus. **d**) Vulva. Bat, an early form of Hathor also resembles a woman's reproductive organs. **e**) An Egyptian fertility amulet that symbolizes both a cow's head and a woman's reproductive system, •3500. **f**) An Isis Knot's uterus-shaped head is a Heraldic Sun, •1300. The Isis Knot is often combined with a Djed Pillar, which represents Isis' husband Osiris' backbone, thereby uniting them on another level.

The Isis Knot (Tet) is a woman's sacred symbol that first appeared early in the Old Kingdom (•2686~•2181). It *"may have been a conventional representation of the uterus, with its ligatures and the vagina"* (**M**ercatante, 189). The Isis Knot's unique shape corresponds to a woman's reproductive organs, which resemble a cow's head and horns. Other ancient cultures have made this connection.

An Isis Knot also represents a folded piece of fabric used during menstruation (**A**ndrews, 44), and there are spells for *"the insertion of a knotted cloth into the vagina"* (**P**inch, 130) to stop bleeding. The knot below the uterus/Heraldic Sun may serve that purpose. *"Sometimes the role of the knot is to prevent something from happening until the right time, such as the birth of a child"* (**M**anniche, 2:84).

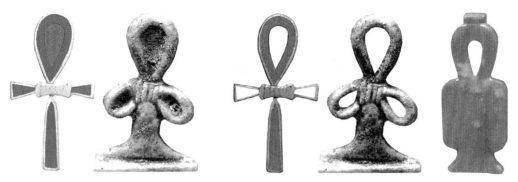

How are the Knot of Isis and the Ankh related? They each have a tear-shaped Heraldic Sun head, similar binding, arms and body, though the Knot's arms usually droop and it has a wide base. The Ankh's horizontal arms suggest the horizon, above which its Heraldic Sun is rising. Both, by virtue of their Heraldic Sun/uterus heads, are birth and resurrection symbols. The Isis Knot is more feminine, with softer lines and more specifically feminine connections.

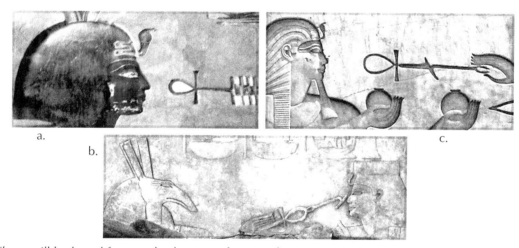

a.

b.

c.

"There will be bread for your body, water for your throat, and sweet air for your nostrils" (CT, 20).

An Ankh as life restorer. a) An Ankh/uterus being held up to a Pharaoh's nose to resurrect him. Its teardrop Heraldic Sun is colored white to symbolize fresh air and light. This Ankh connects to a Djed Pillar, which connects to a Was Scepter. **b)** An Ankh connected to a Was Scepter – Gods and Goddesses are often shown with one in either hand. **c)** Here the normal arrangement is reversed and Seth, god of chaos and death (Part III), is holding the Ankh with the Was Scepter, a Sethian symbol, closest to the Pharaoh's nose.

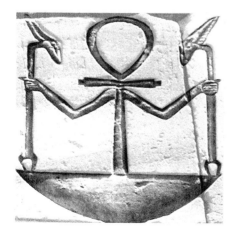

An Ankh as a peacemaker. An Ankh separates 2 glowering Was Scepters. Another Ankh is is shown holding a fan of petals or feathers, a peacetime symbol. The Was Scepter holds a long bow used for killing. These Was Scepters display Sethian natures (Part III).

Composite Faces

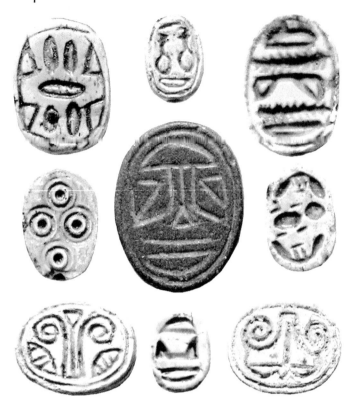

Glyphs are arranged on the bottoms of some Scarabs to form faces. Composite and hidden faces are common aspects of Egyptian symbolism. These Scarabs, each with a composite face on the bottom, can be inverted to reveal a second face. All these examples are internally symmetrical, except the middle-right one, which nearly is (its eyes are formed by a Scarab pushing the Sun from left to right). Scarabs symbolized Dawn and resurrection and were by far the most numerous amulet. It is a relatively easy shape to make, and the flat bottom provided a good surface for text and imagery.

The purpose of Egyptian art was not so much to satisfy one's aesthetic sense but to fulfill the objectives of cult and magic.

Manfred Lurker (8)

 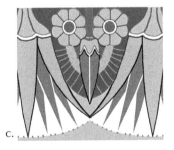 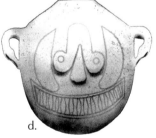

a. b. c. d.

Composite faces are found throughout ancient Egyptian art. a) The frightened look on this heart symbol is understandable since its eternal afterlife depends on it being judged lighter than a feather of Maat – i.e. with minimal sin. Its arteries resemble ears; the Cobra-Ring on top looks like red hair, and the red Sun and crescent moon form its eyes and mouth. It's done in Four Colors. **b)** A stone offering table, resembling eyes, nose, and gaping mouth with an arrangement of food in it. It says "consume this," just as depictions of ears plead "hear my prayers." **c)** This bird, made of Waterlily and papyrus features, is part of a "decorative" border. **d)** A cult flask with geese for ears, an inverted Heraldic Lily for nose and eyes, and an arrangement of Blue Waterlily petals or buds form his toothy smile. It also resembles a large boat under sail.

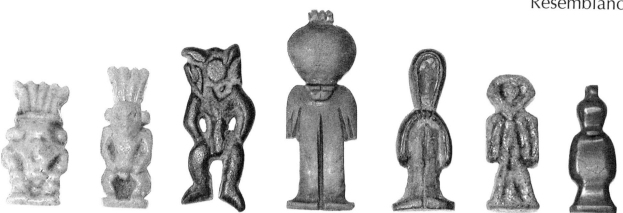

Egyptian artists experimented with similar shapes. These figures are all similar. The 4 amulets on the left are of god Bes; the 3 on the right are Isis Knots; both types are associated with women. The alien-looking one in the middle combines their features. The dancing bronze Bes is the only one of these that is animated and not center-balanced. *"The amulet's shape, the material from which it is made, and its color were crucial to its meaning"* (Carol Andrews, *The Ancient Gods Speak*, page 9, 2002). These are made of bronze, slate, red jasper, and different colored faience.

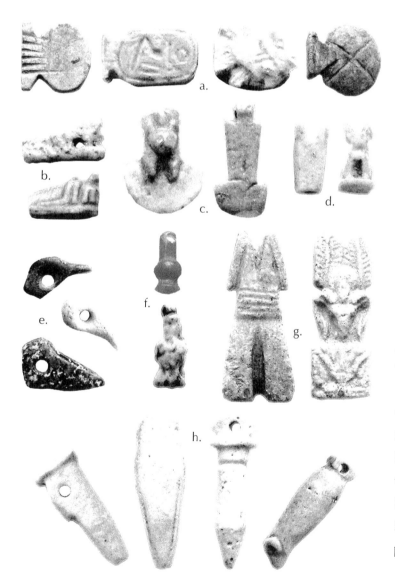

Some amulets were made to resemble others, to expand their power. a) Shen, Shenu, fish, and Sun Disk all have fish-like bodies and tails – the Sun 'swims' across the Waters of Chaos overhead. The Sun Disk bases can be turned on their sides. However, a Sun Disk is always upright. **b)** Crocodiles and locusts both destroy crops. **c)** An Aegis pendant and counterpoise, which hangs behind a person to balance a heavy pendant. **d)** Fortresses and cats both defend homes. **e)** Duck head, claw, and foot. **f)** Pomegranate and corn-cockle flowers. **g)** A pesesh-kef used in an Opening of the Mouth Ceremony, and creator god Khnum over a Waterlily bloom. Khnum wears Two Feathers, a cobra, and a Sun Disk. **h)** A foundation cone, Waterlily bud, papyrus, and ram-headed pillar. It was not necessary for the artist/priest to know the full meaning of the symbols he or she used – art can be a discovery process.

ANCIENT EGYPTIAN CROWNS

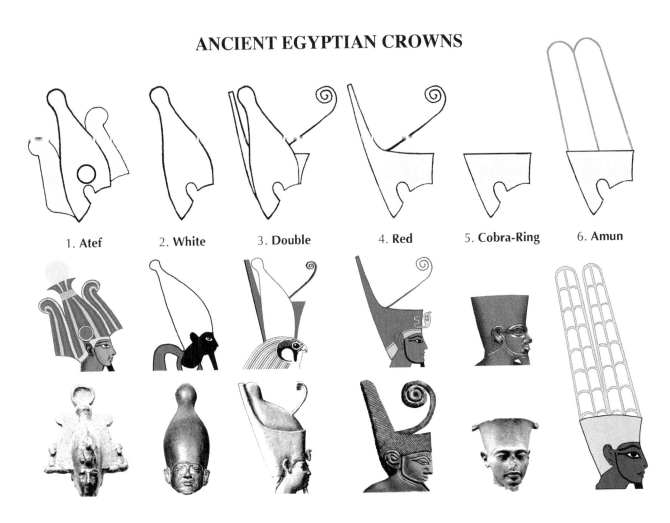

1. **Atef** 2. **White** 3. **Double** 4. **Red** 5. **Cobra-Ring** 6. **Amun**

A number ancient Egyptian crowns were designed using a few common elements. Crowns **1–3**) each includes a White Crown. **3–6**) have Cobra-Ring bases. **4**) is a Red Crown and **3**) is a Double Crown; both have backs/cobras that rise above their Cobra-Rings. **5**) A Cobra-Ring Crown stylization and **6**) an Amun Crown. Double, Red and Amun Crowns all include Cobra-Rings, to which are added optional cobras, curls/ horns, feathers, and Suns. Goddesses, Gods, and royalty are depicted wearing these crowns. Except for a few gold and silver Seshed Crowns, no other crowns have been found, which is strange considering how often they're depicted. Shouldn't some at least have been found in Tutankhamun's intact tomb? Crowns were symbols used in art, often as resurrection machines – an image can potentially jump-start someone's resurrection. These crowns went virtually unchanged for nearly 3000 years because they were based on natural forms. Men's crowns usually fit tightly over their hairlines, covering their scalps. Women's crowns tend to be smaller and sit on top of their wigs. Crowns come in a variety of colors: White Crowns can be blue, gold, or tan; Red Crowns can be blue, and Atef Crowns come in every available color. **7**) Blue Crowns are often covered with Sun Disks. A circle with a smaller circle in the middle is the hieroglyph for Sun, which resembles both a Waterlily's center and a woman's breast, two other important life symbols.

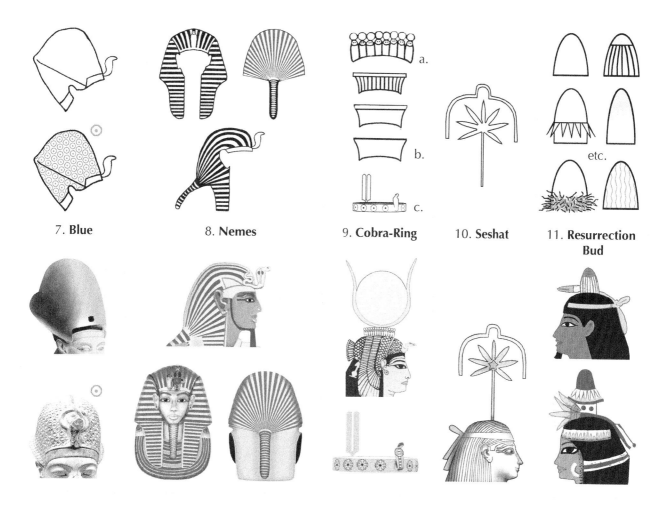

7. **Blue** 8. **Nemes** 9. **Cobra-Ring** 10. **Seshat** 11. **Resurrection Bud**

8) Pharaohs are often shown wearing Nemes Crowns. The first one appeared on a statue of Djoser, •2650. The Sphinx also wears a Nemes Crown. They resemble gold and blue striped cloth, and fit tightly over the head, with 2 lappets (strips) hanging down in front. The material is gathered in back and bound at the end. 9) Cobra-Rings. 9a) A crown consisting of a row of realistic cobras, each with a Sun on its head. The 3 crowns below it are stylizations of it. 9b) A Platform Crown is a Cobra-Ring stylization. A crown was an important chance to positively influence a person's resurrection. The opportunity would not have been wasted on a mere platform. 9c) The bottom crown is a Circlet, or Seshed's Crown, which is a Cobra-Ring stylization. Cobra-Ring Crowns are combined with an assortment of other crowns, and can include cobras, horns, feathers, and Sun Disks. A crown is a resurrection machine when it includes a Sun Disk, a Cobra-Ring, or any Blue or White Waterlily symbolism. 10) Seshat's Crown represents a marijuana leaf under a breast/ Sun symbol. 11) Resurrection Buds are based on the White Waterlily's stamen cluster and often display its stamen lines. As with the Atef Crown, Resurrection Buds vary, but usually include a red or yellow-topped, egg-shaped Bud – so as not to resemble a Sun Disk, which was restricted to nobility, Gods, and Goddesses). The Resurrection Bud is a commoner's White Crown without a top Sun showing – it's implied.

Egyptian Gods and Goddesses were nothing more or less than the elements and forces of the universe. The Gods did not just 'control' these phenomena... they were the elements and forces of the world.

James P. **A**llen (2: 43)

Anything that exists becomes exhausted and needs regeneration, which can be achieved only through the temporary removal and negation of existence.

Erik **H**ornung (181)

Part III

Mysterious Seth and the Eye of Horus

Seth

Seth is invisible. *"Save me from that god who lives by slaughter, whose face is that of a hound and whose skin is that of a man. It is he who is in charge of the interior of the Lake of Fire, who swallows shadows, who snatches hearts, who inflicts wounds, who is invisible. As for that god who takes souls, who laps up corruption and lives on putrefaction, he is Seth"* (CT, 335). Seth is invisible, so one is never sure where or when he will turn up. Bad-timing is his hallmark. *"Throw off the earth which is on you! Get rid of the two arms behind you, namely Seth"* (CT 251).

Ancient Egyptians believed they lived in a fragile world – a bubble of air and earth surrounded by the infinite black waters of Chaos, which with every flood and storm threatened to come crashing down on them and drown the world.

Seth was ancient Egypt's desert god of Chaos, confusion, and storms, and though Egyptians excelled at refining symbols to their simplest recognizable forms, he was an anomaly whose features have, thus far, defied identification.

Other Gods and Goddesses are represented with clearly identifiable features, but not Seth. His body is depicted as that of either a canine or a man, and his head is unlike any known animal. His large ears are square-topped, and his snout curves down to a point, so it often resembles a bird's beak.

Seth's head has been attributed to various animals: greyhound, camel, antelope, ass, aardvark, giraffe, hog, hare, tapir, and others (te Velde, 13), but none is a particularly good match, neither its shape nor its symbolism. **What did Egyptians have in mind when they designed Seth's head?**

Seth's head most resembles a jackal's. In his animal form, he typically has a jackal's body and is, therefore, related to jackals and canines by resemblance. Death is part of all of their identities.

Seth is identified as the murderer of Osiris, by drowning, and then by hacking. *"Seth is god of death, as appears from the myth of Osiris"* (te Velde, 25). What does this symbolism signify?

Osiris symbolized fertile land, and every year it inundated: *"The god's [Osiris'] drowning, which symbolized the flooding of fertile land"* (Lurker, 93). Seth symbolized the inundation's destructive power and Osiris symbolized its fertility. Seth/flood drowns Osiris/soil killing him for the first time.

After the inundation had receded, Osiris' death and resurrection were celebrated with a 10-day plowing and planting ceremony called the Osirian Festival of Khoiak. Then, Osiris was killed again, this time by cutting. *"The rite of hoeing the ground could specifically allude to the death of the god Osiris, who was symbolically buried each year in the form of the planted grain"* (Wilkinson, 1: 191).

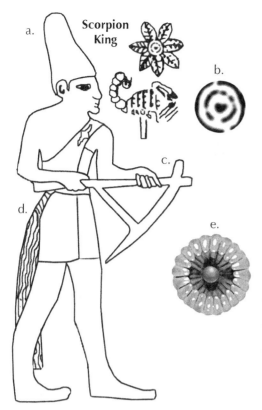

Scorpion King's Ceremonial Macehead details, •3000. **a)** The king wears one of the 2 earliest known White Crowns. **b)** This flower's center resembles a Waterlily's. **c)** A hoe, probably for a "Hacking the Earth" ceremony. **d)** A horse's tail (Hierakonpolis mural horses, •3500) – a bull's tail only has long hairs at its tip. **e)** Realistic golden Waterlily center, •3000. **f)** Earliest known Seth-animal, with squared ears and arrow-tail. **g)** One of 7 birds said to symbolize Lapwings and foreigners, shown hanging from 7 standards on the Macehead. They have large ears, eyes and beaks, and thick human legs and feet. **h)** A Lapwing is different in *every* detail. It (**g**) is not a Lapwing (**h**), but it may represent foreigners. Seth is also known to represent foreigners.

The ancient Egyptian year had 3 seasons: **Akhet**/inundation, **Peret**/plowing and **Shemu**/harvest. The Osirian Festival of Khoiak came at the beginning of Peret.

What significance did a plow have for Osiris/soil? It cut him up. Seth symbolizes a plow, and his fratricide is a farmer's metaphor, reinforced daily as Egyptians toiled under that intense Sun, struggling with their plows/Seth. A plow may have killed Osiris, but it also brought him back to life – cutting him in a natural Opening of the Mouth Ceremony (plowing). This dualistic connection would have reinforced their belief that it was the Gods' handiwork.

 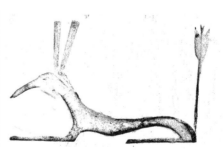

The Seth-animal's arrow-tail goes straight into him on the Scorpion Macehead (top **f**), but in these later depictions, it only grazes him. It was unwise to antagonize Seth; he was, after all, a God. The undecorated limestone macehead (Sethian) in the center, would have been mounted on a shaft and used as a club in battle – it resembled these Seths' tails. The Scorpion King's Macehead (top) was purely ceremonial.

What inspired Seth's unique head?

Osiris represents fertile earth.

In ancient Egyptian myth, Seth kills his older brother Osiris twice:

1) Seth drowns Osiris = during the inundation Osiris/earth is underwater (Lurker, 93).

2) Osiris is revived, then Seth cuts him to death = What cuts the earth?

"The Osirian festival of Khoiak began with the plowing and sowing ceremony, which symbolically corresponds to the death, dismemberment and interment of Osiris in the earth" (Naydler, 2:244).

Osiris *is* the earth.

The hoe and plow hack and cut the earth. Do they resemble Seth?

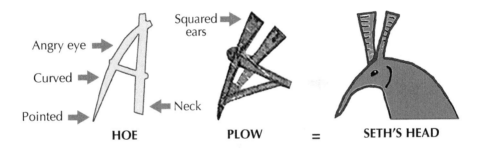

The hoe and plow hack and cut the earth = Seth hacks and cuts Osiris (myth).

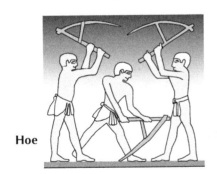

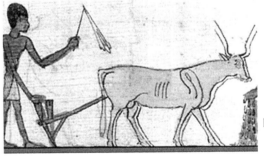

Seth's *"long curved snout seems to have intrigued the Egyptians. They had a story that when Seth was forced to bow down deeply before Osiris, he hit his nose so hard that blood ran out. Ra immediately buried this blood, and thus arose the ritual of* **hacking the earth**" (te Velde, 17, footnote 6). In both these pictures Seth/hoe/plow is being forced to bow to Osiris/earth, with his nose *"hacking the earth."*

Osirian mythology is based on farming.

HOE & PLOW

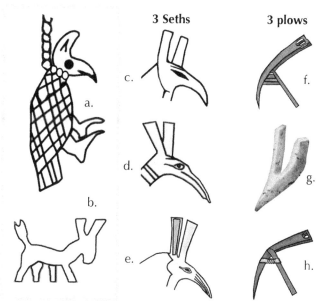

3 Seths

3 plows

a.

b.

c.

d.

e.

f.

g.

h.

Were there any other inspirations for Seth? a) A Sethian birdman from the Scorpion Macehead. **b)** The first Seth-animal has mutilated ears and an arrow tail. **c–e)** Three Seth heads. **f–h)** Three plows. **a)** Seven hanging birds are depicted on the Scorpion Macehead. Birds were a farmer's enemy because they ate seeds and were, therefore, expressions of destruction, or Seth. Notice how similar **a)** the bird's head is to **c)** Seth's head. Seth's head represents a plow, but it also resembles a bird's beak. This resemblance is an example of the Goddesses and Gods' brilliance in combining 2 of Osiris' mortal enemies - plows and birds - into 1 common shape.

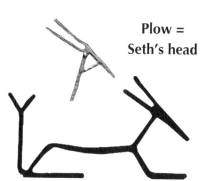

Plow = Seth's head

Egyptian painting of a zoomorphic plow, •2620. This 4th Dynasty depiction of a plow closely resembles a Seth glyph from approximately the same period. The farmer is holding a simple plow/Seth by its handles/ears, forcing its plowshare/ snout into the ground. The 2 oxen pulling the plow, which is "cutting Osiris to death," must pay for their part in his killing, so *"Seth's execution was symbolically carried out in the form of the slaughter of an ox"* (**A**ssmann, 1: 68). Seth, being invisible, can't be caught and punished, only the oxen he uses to do the killing can.

a.

b.

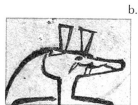

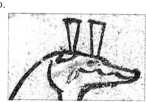

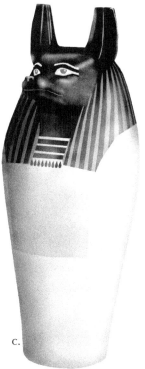

c.

Seth's mutilated ears. a) Anubis stands behind Seth as a killer crocodile (a crocodile's ears are actually slits on top of its head that close when it submerges). All militated ears are Sethian, disempowering that Sethian animal. **b)** Killer crocodiles. **c)** A Duamutef Canopic jar. Duamutef means, "He adores his mother."

Seth...exists on the boundary between the transitory and the everlasting.
The same boundary separates order and chaos, the existent and the nonexistent.

Eric Hornung (158)

Why aren't Anubis' ears mutilated? Because he was usually thought to be an ally of mankind. He was known primarily as a mortuary god, god of mummification. A priest wore an Anubis mask during the last part of the mummification process, temporarily becoming Anubis by resemblance. Here he makes some final adjustments to a sarcophagus. Anubis' most important role was to help the deceased resurrect and achieve an afterlife.

Anubis prepared the deceased's body for resurrection. Mummification involved first cleaning the body, then making a cut in the left side, just above the hip, with a knife like the one above. Next, the internal organs were removed, washed,

wrapped separately, then packed in salt for 40 days to absorb the moisture. The body cavity was cleaned and filled with rags and sawdust, the incision covered, the body wrapped in fabric strips, and finally returned to the family for burial. Often, amulets were strategically placed under the wrappings. Not everyone could afford such elaborate preparations, and ironically, bodies simply buried in the desert sand were often better preserved than those that had been mummified (**A**llen: 2, 94). There are 2 sets of Waterlily sepals on this knife's handle, which ends with a Waterlily/papyrus. The Waterlily/Sun symbolism helps purify the knife.

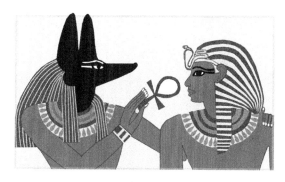

Anubis revives. One of his duties is to awaken the deceased. Here he uses an Ankh (Life) filled with life/fresh air – a welcome relief for anyone who has been mummified and sealed in a coffin. The Ankh's Heraldic Sun resembles a uterus, creating birth/resurrection symbolism. Ankh is the hieroglyphic sign meaning "life."

Anubis escorts the deceased to his heart's weighing, and assists. Anubis kneels and checks the plum-bob to ensure an honest weighing of the deceased's heart against the feather of Maat (justice). Ammut waits to devour any overly heavy hearts. She is a Death symbol and combines 3 animals known to kill humans: lion, hippopotamus, and crocodile.

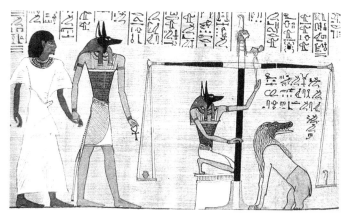

Seth, Anubis and the Jackals

Compassionate Anubis listens to an appeal. He holds an Ankh in one hand and a Was Scepter in the other. Behind him is a Shenu (royal name) with 2 sets of horns, a Two Feather Crown, and a Sun Disk. The Shenu rests on the symbol for gold, which has 12 Heraldic Suns dripping below it. Horizontal horns were considered masculine, upright horns feminine (V). Here, Hathor's horns are combined with Khnum's horns, with Ra's birth being the result.

One of two types of mummy cloth used is called Seth...but once it is thus called, it must be made harmless, and so some threads are drawn out. This counts as the removal of Seth's legs. The other material, a purple cloth, is identified with Osiris.

Henri Frankfort (1: 137)

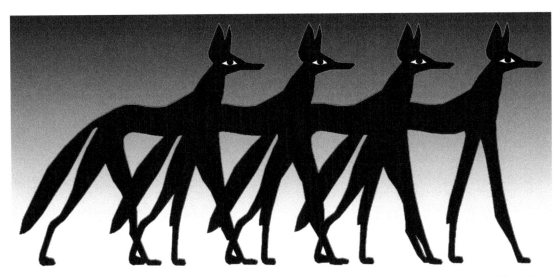

"The Four Seths" (CT 1143). These jackals don't appear to have enough legs because 2 of their legs line up behind others and cannot be differentiated. Giving them too few legs was a way of wounding these Sethian creatures. Red outlines and background added.

THE MOVING FINGER WRITES AND HAVING WRIT, MOVES ON. NOR ALL YOUR PIETY NOR WIT SHALL LURE IT BACK, TO CANCEL HALF A LINE NOR ALL YOUR TEARS WASH OUT A WORD OF IT!

NOW IS THE ONLY TIME YOU OWN! DECIDE NOW WHAT YOU WILL. PLACE FAITH NOT IN "TOMORROW" FOR THE CLOCK MAY THEN BE STILL!

The site of the epic 80-year battle between Seth and Horus, later said to be where Saint George encountered the dragon, is now the location of the Coptic Church of Saint George, Old Cairo. Halfway up the front stairs is a white marble sculpture of Saint George slaying the dragon. Aggressive, carnivorous Komodo dragons grow up to 10 feet long, which is the length of this one. The upper quotation is from Omar Khayyam, 1100•; the lower one is anonymous. These 2 poignant signs stood in front of the church for many years, then disappeared in the late 1990s.

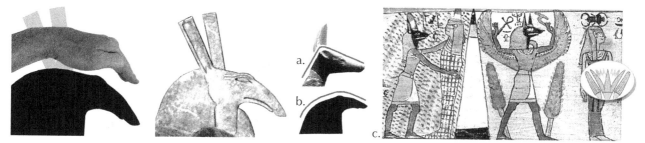

A symbol's shape conveys important information. **a)** This jackal's neck is at a right angle to his head, whereas **b)** Seth's neck often arches. Death would have been an important character in stories told around a fire. Some of those stories employed shadow figures. Seth's head and neck could easily have been created with one hand and wrist, and a folded palm leaflet for ears. Then, by simply moving one's little finger, Seth appears to speak. Death/Seth did not have a shadow, but, in this case, ironically, one was used to represent him. Shadows are one of the 5 essential elements that make up a person, along with their Ba (personality), Ka (life force), physical body and name. Without a shadow, Seth is an incomplete being, or no being at all – the opposite of being. **c)** A priest, as Anubis, makes final adjustments to a sarcophagus. An Anubis-priest sprouts wings and assumes a common Blue Waterlily-Sunrise pose (inset).

Was Scepter

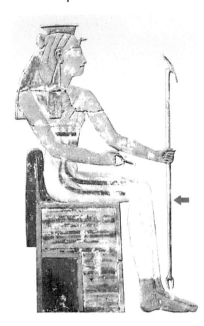

What inspired the Was Scepter? It's said to symbolize power and dominion, and its earliest depiction is on an ivory comb, •2900 (right). Two engraved Was Scepters are shown supporting the sky, represented by a pair of wings (to be later replaced with a glyph for sky, opposite). These symbols combine to form an anthropomorphic image with wings for shoulders; directly above those are jaw, teeth, hair, and a bird for the nose. Was Scepters form the arms. Gods and royalty are often shown holding an Ankh in one hand, and a Was Scepter in the other (left).

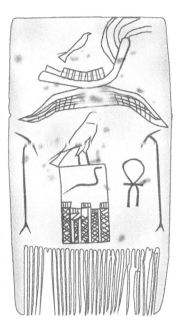

Much is known about the Was Scepter, with its canine head and forked tail. However, its inspiration and full meaning have proven elusive.

The Was Scepter's head has canine features, and Seth, who preceded it by 200 years, has been suggested as its likely source. Seth even takes the Was Scepter's place holding up the sky on several occasions. *"As supporter of the sky, Seth is appealed to in a prayer of Rameses II"* (te **V**elde, 90).

Nothing could overpower Seth/Death. His strength and sovereignty were supreme, and exactly what was needed to support the sky and hold back the Waters of Chaos. However, it was unwise to give Seth that responsibility because, although incredibly strong, he was also dangerous, unpredictable and deadly.

What was needed was a symbol that isolated Seth's positive qualities, while excluding his less desirable ones. The Was Scepter became that symbol.

When viewed horizontally, the Was Scepter resembles a plow. That makes sense because the Was Scepter's head resembles Seth's head, which was inspired by a plow. The Scorpion King is depicted holding a hoe (opposite), serving to indicate the importance it had as a symbol for ancient Egyptians.

The Was Scepter's staff has a sharp bend in it, just below its head, which only serves to weaken it as a staff, plow or sky-support. That bend symbolizes the wounding of any dangerous Sethian elements lingering in the Was Scepter – it represents Seth's broken neck. Seth was, after all, Osiris/soil's killer.

A plow is used horizontally; a staff is used vertically. A Was Scepter, or vertical plow, symbolizes a time when plowing and planting are finished; a time of healing and resurrection.

Was Scepters have Anubis' ears, Seth's snout (plow/beak), a plow's staff (cobra/Seth), and Seth's forked arrow-tail and broken neck – essential woundings to neutralize him.

SKY

"This right hand of mine will support the sky with a Was-staff" (PT, 511).

Was Scepters supporting a) an Egyptian glyph for sky, which was originally represented by a pair of wings (opposite). **b)** Part of a plow was eliminated to make the Was Scepter's head and neck. **c)** The bend symbolizes Seth's broken neck. Egyptians didn't have to remove the **d)** angled piece of the plow at all. Leaving it would have made it a stronger staff or support; they intentionally chose to weaken it. The Was Scepter's forked tail **f)** forms the glyph for "obstacle," which is also Sethian. Its reverse **e)** symbolizes Seth's tail and the glyph for "support," needed for the sky. The down-pointing fork resembles little legs, making the Scepter more stable to lean on, or to support the sky; it would, however, be ackward to use as a staff.

"The word w3s [Was] *means dominion* (te **V**elde, 90), and it was *"associated with prosperity and well being...in the Pharaonic period"* (**S**haw/**N**icholson, 304).

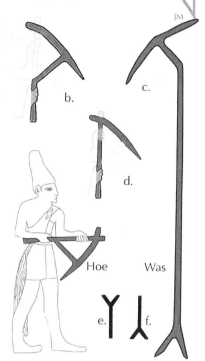

The Was Scepter as a plow. **a)** An early glyph of the Seth-animal with its characteristic head and tail. **b)** Two bovines pulling a plow, **c)** then pulling a Was Scepter. The bend in the Was Scepter's neck must be straightened to make a workable plow (**b**). **d)** A Was Scepter's 2-prong end suggests it splits to attach to 2 animals. A plow and a horizontal Was Scepter both appear to be bowing to Osiris/earth with their snouts in the earth – a farmer's metaphor. On the Scorpion Macehead, the king holds a hoe, progenitor of the plow, which inspired both Seth's head and the Was Scepter. **A Was Scepter is a plow at rest**. In the hands of Gods, Goddesses, and royalty, a Was Scepter is said to symbolizes "strength and dominion."

Was Scepter

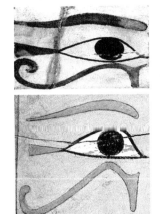
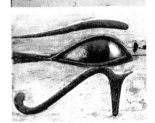
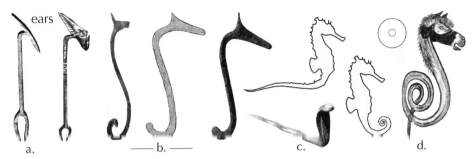

Was Scepters resemble the Eye of Horus' drop and curl. a) Two Was Scepters. **b**) Three Eye of Horus drop and curls from a boat and 2 coffins. They have curls instead of forks. **c**) Seahorses inhabit the Mediterranean and Red Seas, and when they stretch out their tails on the bottom to rest, which they need to do frequently because they have tiny fins, they resemble rearing cobras. **d**) This horse-headed fantasy, •850, is an Eye of Horus' drop and curl variation with its coils forming a Cobra-Ring (Sun glyph), just as cobras do on many Blue Crowns. It resembles a seahorse (coffin, page 39). Seahorses usually curl their tails in front of them.

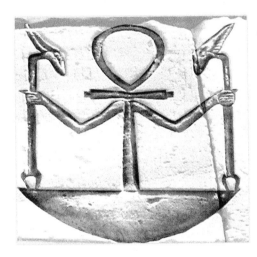

Ankh peacemaker separates 2 scowling Was Scepters. Was Scepters represent Seth's strength and dominion. But, by their angry expressions, these 2 (left) suggest that anything associated with Seth will be dangerous. The Was Scepter on the right holds a long "war" bow.

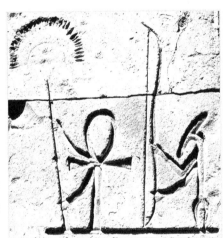

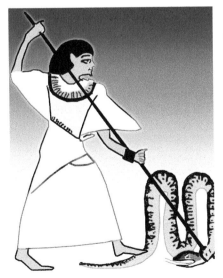

Using a forked stick, or partial Was Scepter, to pin down a snake is an example of using a force against itself – both are long, narrow, forked and Sethian. *"One of the basic principles of Egyptian magic was that like should be fought with like"* (**P**inch, 32).

Another example of using a force against itself is Seth's defense of Ra and the Solar Boat against the nightly attacks of Apophis, who, like Seth, represents death. *"Apophis was equated with Seth"* (**L**urker 29). Apophis/death cannot be killed, and is always recovered and ready to attack again the following night. Sky added.

"I have fallen down and have crawled away because I am he of the Was Sceptre" (CT, 414). Seth/serpent.

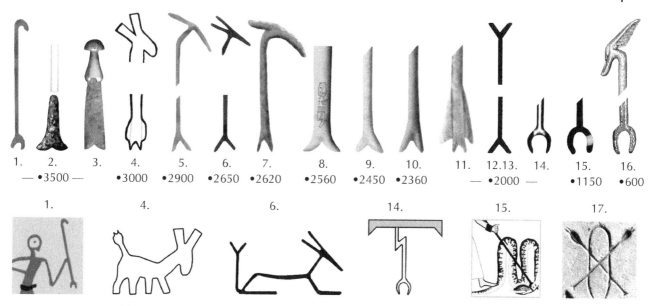

An assortment of forked ends from ancient Egypt: **1**) Possible Was Scepter prototype from a Hierakonpolis tomb painting; its head is a crook, which became a royal symbol. **2**) Ceremonial spear point sharpened to cut on both the thrust and withdraw. **3**) Ceremonial knife. **4**) Seth-animal from the Scorpion Macehead. **5**) First Was Scepter, from an ivory comb. **6**) Seth hieroglyph. **7**) Was Scepter bas-relief. **8**) Pesesh Kef to revive the dead. **9, 10**) Boat poles used for mock battles. **11**) Bas-relief depiction of an arrow used for a real battle. **12, 13**) Glyphs: "support" over "obstacle." **14**) A lightening glyph with Seth's tail or cobra fangs. **15**) A forked stick used to pin down a snake's head. **16**) A Was Scepter. **17**) Crossed arrows with forked tails. All these forks are related to violence and have strong Sethian associations.

An Egyptian Cobra's body includes 3 relevant symbolic forms. **a**) Some of its scales are teardrop shaped and so resemble Heraldic Suns. **b**) Its tongue is forked, with straight sides like some Seth or Was Scepter tails. **c**) And, its fangs and gums are U-shaped, like some other Seth and Was Scepter tails.

Eye of Horus

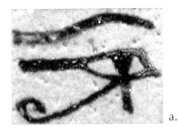
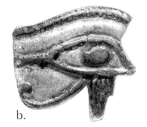

a. b.

Eye of Horus a) is the <u>symbol</u>, and **b) Wedjat** is the <u>amulet</u>. The Eye of Horus appears frequently in the funerary texts being used to revive the deceased king to begin his afterlife. It is mentioned 80 times in one *Coffin Texts* Spell alone (936).

The **Eye of Horus** is one of the most recognizable symbols from ancient Egypt. The many artifacts and drawings brought back to Europe from Napoleon's invasion of Egypt in 1798 introduced ancient Egyptian symbolism to a fascinated public. Now, after more than 200 years, does the Eye of Horus have any secrets left to reveal?

Osiris, Horus, and Seth are key Gods in ancient Egyptian mythology. Their story is iconic. Seth grows jealous of his older brother Osiris and murders him. Osiris is resurrected, and Seth murders him again. Later, Isis bears Osiris' son, Horus, who she hides until he reaches manhood. Then Horus and his uncle Seth fight for 80 years for the right to rule Egypt.

Seth tears out Horus' eyes and Horus castrates Seth, after which both have their missing parts restored. Horus' restored eye is the Eye of Horus and symbolizes healing and the restoration of wholeness. Seth symbolizes the opposite: death, chaos, storms, dissolution, pain, and destruction. Together *"Horus and Seth were the antagonists per se — the mythological symbols for all conflict"* (Frankfort, 1: 22). They were the prime example of Egyptian dualism, which held that for a thing to be complete, it had to include its polar opposite, from which it was inseparable.

The Eye of Horus plays a significant, but widely overlooked role in the *Pyramid Texts* (●2350) the most important body of spiritual writing from ancient Egypt. The Eye of Horus appears in 120 of the first 200 Utterances (prayers), and in nearly 1/4 of all 759. It appears in the other 2 major funerary texts, as well, *The Coffin Texts* and *Going into the Light,* and was a highly revered symbol.

The Eye of Horus is used to revive the dead king in 2 principal ways: by becoming food or drink, to tempt the king to open his mouth (~60 Utterances), and actively, by splitting open the king's mouth (~12 Utterances).

Splitting the mouth, eyes, and/or ears is sometimes performed using a blade made of "Seth's iron." Seth is the god of metals and his, and the king's bones are said to be made of iron (PT 684). That the Eye of Horus is also used to split open the king's mouth, indicates it includes a Sethian element, an iron blade; it suggests Seth is part of the Eye of Horus.

- *"Oh King, take the Eye of Horus which you shall taste – a dpt-cake"* (PT, 51). Using cake to tempt the king to open his mouth and revive.
- *"Split open your mouth by means of the Eye of Horus"* (PT, 93).
- *"He split open the mouth of Osiris, with the iron which issued from Seth"* (PT, 21).

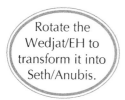

Rotate the Wedjat/EH to transform it into Seth/Anubis.

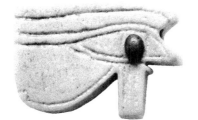

Wedjat/Eye of Horus

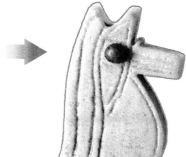

Seth/Anubis

Ancient Egyptian funerary text quotes:

- *"My Shape is that of the Double God Horus-Seth"* (GL, 180).
- *"Seth will swallow the Eye of Horus"* (CT 587). Seth-position.
- *"Seth is Released from the Eye of Horus"* (CT, 841). Seth-position.
- *"The Eye of Horus which Seth had hidden"* (PT, 752). Seth-position.
- *"I am Horus who went forth as Horus and Seth"* (CT, 524). Eye-position.
- *"I am Horus who absorbed the Chaos god [Seth]"* (CT, 841). Eye-position.
- *"Seth, who made the Eye of Darkness, passed by"* (CT 1138). Seth-position.
- *"Who is he? He is Anubis; he is Horus the Eyeless"* (GL, 17). Horus is eyeless in the Seth-position.
- *"I am he who dwells in his Eye; I have come that I may give Maat to Ra"* (GL, 96). Seth protects Ra.
- *"The glorious Eye of Horus comes...it drives off the powers of Seth"* (GL, 137b). Eye-position.
- *"I am one invisible of shape, I am merged with the sunshine god"* (CT, 75). Seth in Eye-position.
- *"O King [Horus], your shape is hidden like that of Anubis on his belly"* (PT, 677). Eye-position.
- *"You are possessor of different forms, rich in hues, one who hides in the Sacred Eye until his birth"* (GL, 162). Seth hides in the Eye-position.

These quotations refer primarily to Seth, but the Wedjat's ears are usually more like those of Anubis. Anubis is much safer to be around, and so he is often made to stand in for Seth/Death.

The Eye of Horus is described in *The Pyramid Texts* as being *"stronger than men and mightier than the Gods"* (PT, 510). Only Seth is mightier than the Gods because he is Death, to whom all living things must one day submit. To be mightier, the Eye of Horus must include Seth.

The Eye of Horus' drop and curl resemble a Was Scepter on its face, which is its plowing position, an activity that symbolizes Seth cutting up Osiris. Horizontally, a plow resembles Seth bowing to Osiris with his snout jammed into the ground.

Maintaining Maat, or balance and justice, was thought to be imperative for ancient Egypt's survival. The Eye of Horus/Wedjat epitomized that critical balance.

- *"When Horus and Seth are reconciled, they do not fight with one another, but together against the common enemy. The Pharaoh is the representative of Horus, but also the representative of Horus and Seth, who are united and reconciled"* (te Velde, 71).
- *"I am he [Seth] in whom is the Sacred Eye and nothing shall come into being against me"* (GL, 42). Seth, who cannot be defeated, must be part of the Eye of Horus.

Eye of Horus

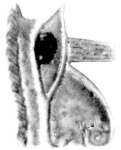 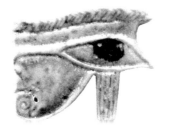

A Wedjat's right eye becomes a left eye when turned over, and Seth/Anubis when rotated.

The Wedjat symbolizes transformation. All one does to make it transform is turn it over or rotate it. Turned over, a right eye Wedjat becomes a left eye Wedjat. Usually, only the right eye is detailed and the reverse left plain; nonetheless, every Wedjat has 2 eyes.

The Wedjat's major transformation occurs when rotated 90º, so its 2 ears point up and it appears to transform into Seth/Anubis' bust. Horus and Seth in the Eye of Horus was ancient Egypt's prime example of dualism (life/death).

A pair of Horus Eyes was frequently painted on the left sides of coffins to allow the deceased to see out. Had they been painted on the portrait on top of the coffin, however, when viewed from either side, one Eye would always be in the Seth-position, which was avoided. This may be the reason why an Eye of Horus is rarely, if ever, depicted on a person's face.

There are numerous references in the funerary texts to Seth being hidden, face down and invisible. As long as the Wedjat remains in the Eye-position it is said to be "intact," and Seth is on his face, disempowered and invisible. Seth/Death is a shape-shifter, which is an ability he brings to the Eye of Horus. He arrives in many different deadly disguises

When the Eye of Horus is rotated or turned over, nothing changes except one's perspective, which suggests **change is an illusion**.

How do the Wedjat and Eye of Horus differ?

The Wedjat transforms into Seth's head and torso when rotated 90° from its Eye-position. The 'thorn' on the Wedjat's snout represents Seth's ear, from the Eye of Horus, which needs it; the Wedjat does not, it already has ears.

Seth's ears

Seth's ear

No ears

Seth's ear

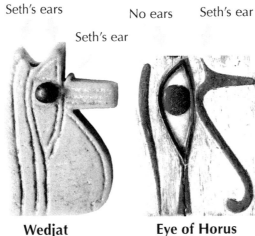

Wedjat **Eye of Horus**

An Eye of Horus doesn't have the Wedjat's ears, so one is added to symbolize Seth. The Eye of Horus' drop and curl resembles the Wedjat's but with a Was Scepter's head. The little thorn on it represents Seth's ear.

Seth/Anubis

Eye of Horus

Seth's butt

Seth on his face

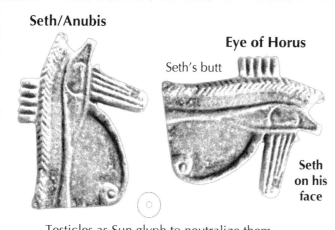

Testicles as Sun glyph to neutralize them.

Horus' lost eyes and Seth's lost testicles evolved as explanations for the Wedjat's shape. In the Seth-position, the curl represents Seth's testicles, which he loses in the Eye-position. Likewise, Horus' eye is missing, or torn out, in the Seth-position. It would be nearly impossible to design a symbol that so perfectly fit the strangeness of the myth, but it is superfluous because the Eye of Horus is based on a more ancient symbol (to be revealed). *"Jackal of the Sunshine"* (CT, 334).

A golden Eye of Horus plaque was sometimes used to cover the incision made in a deceased person's side to remove their internal organs. Anubis and Horus are shown worshipping the Eye of Horus, reinforcing their connection to it; both are essential for resurrection. A two-fingered stone amulet (right) was used to cover a less wealthy person's incision.

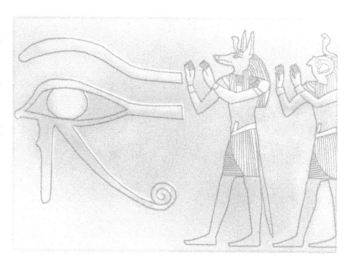

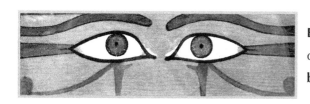

Eyes of Horus from the side of a coffin, painted there so the deceased can see out. The Eye's curls and drops **are in the bowing/plowing position**. Tiny pupils indicate fear.

A Wedjat is legless in the Seth-position. It is a way of wounding him, preventing him from being able to give chase. And, the lines in some depictions of Seth's snout are an unusual feature linking him to the Wedjat, which often has those same lines in its drop. The lines may symbolize the disabling of Seth's mouth with cuts, and perhaps a plowshare laminated for strength.

NO LEGS

Eye of Horus

Turned on edge, most Wedjats resemble legless jackals. *"How alert the ancient Egyptian was to the shape of objects, and to the symbolic importance which the dimension of form could hold"* (**W**ilkinson, 2: 16). The bottom row of Wedjats is from Flinders Petrie's book *Amulets*. Three of these have Seth's ears.

What inspired the Eye of Horus' and Wedjat's curls? The Eye of Horus, the Red Crown, and Hathor have identical curls. The Red Crown and Bat first appeared on Narmer's Pallet (page 67). Bat evolved into Hathor, and her horns became identical to the Red Crown's curl, thereby merging their symbolism. **a**) An Eye of Horus from the side of a coffin. **b**) A Wedjat. **c**) A Red Crown amulet on its face. **d**) A gold and blue paste Lanner Falcon (Horus). **e**) Goddess Bat. **f**) Part of a Hathor sistrum (rattle). **g**) Grapevine tendrils are extremely strong. Grapes were grown for wine (Seth/Shesmu) in Egypt starting •3000. **h**) Lanner Falcon

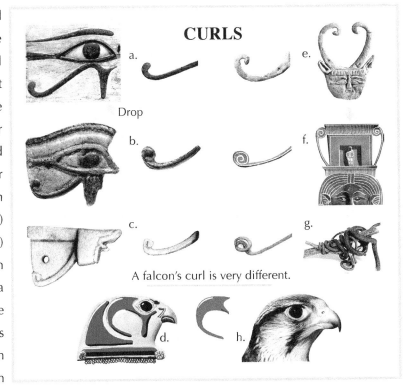

CURLS

Drop

A falcon's curl is very different.

(Lilly M, photo detail, Wikipedia). These curls are all Sethian *except* for Horus' (**d, h**). The Eye of Horus' drop is from a **h**) falcon but not its curl. The upper 6 curls dualistically resemble plant shoots, life symbols.

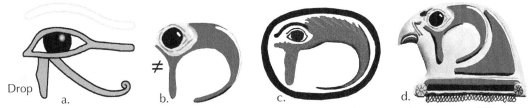

Drop

The Eye of Horus gets its drop from the Lanner Falcon. a) An Eye of Horus. There was a different symbol **b**) based on the Lanner falcon's head markings. **c**) Image from Nefertari's tomb in the Valley of the Queens. The Eye of Horus' curl is Sethian, and resembles a cow's horn, and the striking motion of a scorpion's tail.

Why was the Wedjat made asymmetrical, when balance and symmetry were a goal in art? These are all symmetrical, center-balanced amulets, so that when divided vertically down the middle, the right side mirrors the left. The Eye of Horus' asymmetry symbolizes Seth's presence in it.

These are examples of Horus' Eyes framed or grouped to make them appear more symmetrical. Overcoming the Eye's asymmetry was symbolic of Horus defeating Seth, or order triumphing over disorder. The piece in the left lower corner is the reverse of that in the right lower corner.

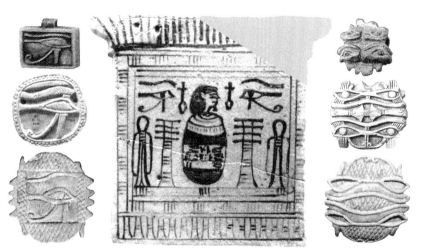

The Eye of Horus was used to represent fractions. Six parts were each assigned a fractional value, descending from 1/2, with each, half of the preceding fraction. All 6 fractions add up to 63/64 (Sethian), which was rounded out to 1 (perfect). Fractions were essential for land, crop, and other business transactions.

1/2
1/4
1/8
1/16
1/32
1/64
63/64

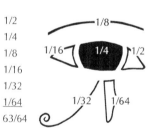

Seth, *"whose testicles are a symbol as a pendant of the Eye of Horus"*
Herman te Velde, 334, *The Ancient Gods Speak*, 2002

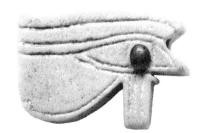

The Wedjat can *"trod down the enemies [Seth] of Osiris"* (CT, 233) by simply being turned from its Seth-position to its Eye-position. The Eye is also a catalyst for healing, but **disaster/ Seth is always just one wrong turn away**.

"Thoth admonishes Horus to incorporate these [Seth's] *testicles in himself to increase his power"* (Frankfort, 1: 130).

Eye of Horus Metaphors

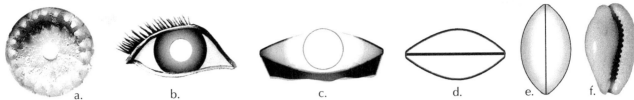

a.　　　　　b.　　　　　c.　　　　　d.　　　e.　　　f.

Waterlily to Solar Eye to Cowry shell, and back. a) A Blue Waterlily's styles and their shadows resemble eyelashes. Its sun looks like a white pupil, which is why Egyptians described the pupil as white (Lurker, 129, asks why). **b**) A right eye with eyelashes and Solar pupil. **c**) Solar Eye and Solar Boat. **d**) A closed eye, when rotated 90° becomes **e**) a sleeping eye or upright vulva. *"I am he in whom is the Sacred Eye, namely the Closed Eye"* (GL 42). **f**) Cowry shells symbolized vulvas in ancient Egypt, as in many cultures, based on resemblance. A cowry's rippled lip resembles a Blue Waterlily's styles (**a**).

Horus is male, so what sex is the Eye of Horus? It and the Wedjat include both male and female symbolism. *"I am that Eye of Horus, the **female** messenger of the Sole Lord"* (CT, 331) and, *"I am the Eye of Horus, the Lady of All* (CT, 946). An eye and its shape were considered feminine, which was a confusing aspect of Horus' Eye. Seth symbolizes male sexual energy, and Horus symbolizes a male falcon and the Sun (right eye) – they both have "feminine" eyes. That was challenging to explain in myth. Hence, the confusion about their possible homosexuality. Egyptians struggled to understand these symbols because they were clues to the meaning of life, and came from the Gods and Goddesses.

Why was the Eye of Horus used as a boat metaphor? Resemblance. Many Egyptian boats were eye-shaped when viewed from above. In Eye of Horus boat metaphors, the curl sometimes is identified as an oar. Seth riding in a Horus boat suggests homoerotic intercourse, and some versions of the myth follow that thread. The other source of that sexual confusion came from the myth of Seth *plowing* Osiris/soil, also a metaphor for intercourse. They tried to make sense of what they observed.

- *"The Eye of Horus: variation 'the boat of Horus,' and 'the Boat of the Eye of Horus'"* (Faulkner, CT, 398, endnote 2).
- *"O Horus-Eye. Your right Eye is the Night-bark, your left Eye is the Day-bark"* (CT, 607).
- *"Horus brings me to land just as he brought the boatless Eye of Horus to land"* (CT, 182). The Eye of Horus is boatless and eyeless in the Seth-position.
- *"Nor am I boatless, for I possess the Eye of Horus"* (PT, 566). Eye-position.
- *"He [Seth] attacks me – so says Horus the boatless"* (CT, 775). Seth-position.
- *"I am Seth about to sail the bark"* (CT 649). Seth-position.
- *"Horus is in command of the Sacred Bark* [Eye of Horus]...*while that Seth, the son of Nut, is in bonds"* (GL 86). In the Eye-position, Seth is *"in bonds."*
- *"The boat of the Eye of Horus, which was rescued from Seth."* (CT, 398, footnote 2).

 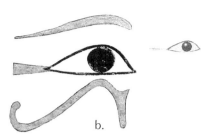 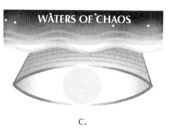 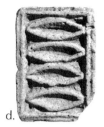

a. b. c. d.

Some Eye of Horus and Wedjat related shapes. a) A fish Wedjat. **b)** An Eye of Horus: its brow is wave-like, its eye resembles a fish, and its drop and curl resemble a Was Scepter and a seahorse. **c)** The Solar Boat sails on the Waters of Chaos overhead, so, Egyptians worried about being upside down in the afterlife: *"I will not go upside down"* (CT, 204, 1013). **d)** Called an 8-eye amulet (4 on either side), they are more likely vulvas (fertility/life/resurrection), or mouths pleading "hear my prayers." Eyes, mouths, and boats all have female overtones based on their resemblance to vulvas.

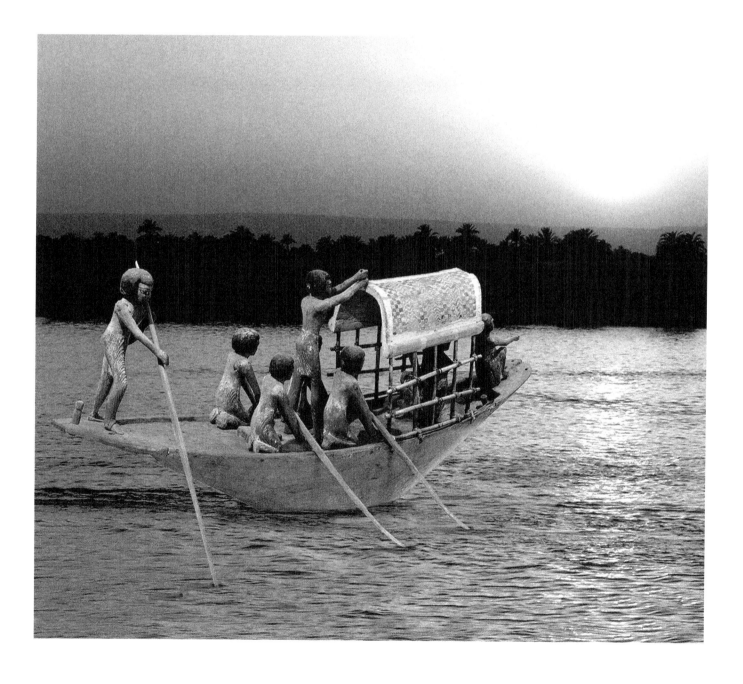

Eye of Horus Metaphors

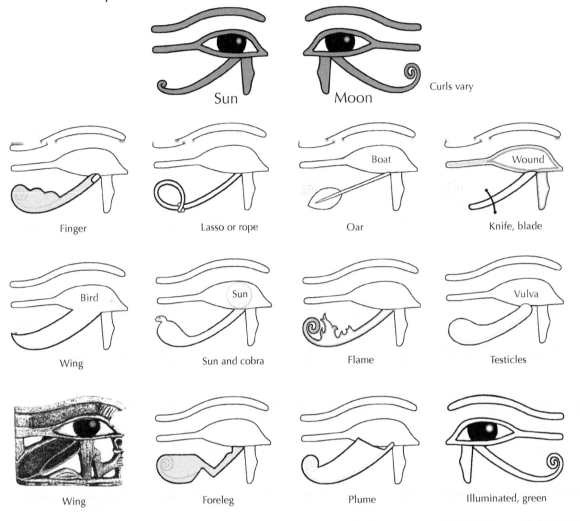

Sun Moon Curls vary

Finger Lasso or rope Oar Knife, blade

Wing Sun and cobra Flame Testicles

Wing Foreleg Plume Illuminated, green

The Eye of Horus/Wedjat inspired a variety of metaphors in the ancient Egyptian funerary texts. Suggesting its curl was a similarly shaped object, added richness and new dimensions to the myth. *"There are many instances where a mythical event has clearly been invented to explain the ritual device or activity, rather than the reverse"* (**G**oelet, 146). Most of these metaphors only existed as mental images, but were an important feature of the funerary texts, ancient Egypt's most sacred writings.

Finger:
- *"I pull out the finger of Seth from the Eye of Horus"* (te **V**elde, 49: Berlin Papyrus).
- *"I loose the finger of Seth from the Eye of Horus. It is comfortable"* (ibid.).
- *"Take the finger of Seth which causes the white [blind] Eye of Horus to see"* (PT, 69).
- *"The white Eye of Horus, which illuminates the tip of Seth's finger"* (PT, 70).
- The Eye of Horus is split, lighted, illumined, and revived by Seth or Horus' finger, which are metaphors for the Eye of Horus' curl.

Lasso, rope:
- Seth *"who snatches hearts, who casts the lasso, but who is not seen"* (CT, 336). Eye position.
- *"Horus secures the rope of Seth when he ferries him across"* (CT, 882).

Oar:
- *"Lord of Turmoil, with face of fire and eyes of flame. 'He who takes the oar'"* (CT, 653).
- *"I know the name of her [Eye of Horus'] oars; it is the shank of Geb and the thigh of the Winepress-god [Shesmu/Seth]"* (CT, 473).

Knife, blade, razor:
- *"Mine is the knife [Seth] which cuts down him who is in the hand of Thoth [the Eye of Horus]"* (CT 246). *"The fiery Eye of Horus, which the hand of Thoth bears"* (GL, 144).
- *"The intact Eye of Horus...a razor-case"* (PT, 756). Seth as a razor in an Eye of Horus case.

Wing:
- *"The Eye of Horus is placed on the wing of his brother Seth, the ropes are tied, the ferry-boats are made ready"* (PT, 615). Boats are Eye of Horus metaphors.

Uraeus, cobra:
- *"Viper in the Night-bark...the Uraeus in the Day-bark"* (PT, 262).
- *"I am the living Uraeus which is pre-eminent in the Bark of Flesh [E/H]"* (CT 817).

Flame:
- *"I am the fiery Eye of Horus"* (CT, 316). *"Horus flames up around his Eye"* (GL, 130).
- *"May the flame [Seth] of the Eye of Horus go forth against you"* (GL, 90).

Testicles:
- *"Horus took away Seth's testicles"* (GL, 17). Eye-position.
- *"Horus carried off the testicles of Seth"* (CT, 335). Seth-position to Eye-position.

Foreleg:
- The glyph of a bovine's foreleg meant "strength," for which Seth was known.
- *"The...of the Eye of Horus — 1 foreleg"* (PT, 20, 126).
 "Take the foreleg of Seth which Horus has torn off" (PT, 61). Seth-position to Eye-position.

Plume:
- *"I...cause the plume to grow into the shoulder of Osiris, to make complete the Red Crown in the bowl and to pacify the Eye for him who numbered it"* (CT, 156; GL, 114).
- *"The plume of the divine Falcon"* (CT, 476, 475).

Illuminated, green, and clear eyes:
- The Eye of Horus is illumined, green, lighted, bright, painted and clear. Eyes (99% water) could not be preserved, hence, the unique importance of a healed eye symbol.
- *"O Osiris the King, take the green Eye of Horus"* (PT, 186,162). Healthy; Eye-position.
- *"Take the two Eyes of Horus...take them to your forehead that they may illumine your face"* (PT, 43). Bring you back to life.

The Wedjat/Eye of Horus is based on the Double Crown.

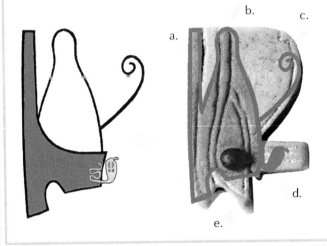

When the Double Crown is right-side up, Seth is upside down.

"The crown [Great Ones of Upper and Lower Egypt] is referred to as the Eye of Horus" (Frankfort, 1: 131).

"Your amputated parts [Eye of Horus] are raised up by the Double Crown" (PT, 437).

"The White-crown Eye of Horus goes up from your head" (CT, 42-3).

The Double Crown's influence on the Eye of Horus' design is unmistakable, and the funerary texts emphasize that connection. All of their major features align: **a)** the eyebrow with the Red Crown's back; **b)** the eye with the White Crown; **c)** the curls; **d)** the cobra with the drop, and **e)** the crown's ear-notch with the Eye's notch.

The Double Crown predated the Eye of Horus by ~480 years (•2950~•2470). The White and the Red Crowns are used in the funerary texts as metaphors for the Eye of Horus.

White Crown:

- *"The dread of you is the intact Eye of Horus, namely the White Crown"* (PT, 468).
- *"The White Crown, wherewith the Eye of Horus is powerful and fulfilled"* (PT, 724, 524).

Red Crown:

- *"O King, I provide you with the Eye of Horus, the Red Crown rich in power and many-natured"* (PT, 468).
- *"Horus has given to you his Eye that you may take possession of the Wrrt-crown (Red) by means of it"* (PT, 367).

Both Crowns:

- *"The Eye has issued from your head as the Upper Egyptian Crown Great-of-magic; the Eye has issued from your head as the Lower Egyptian Crown Great-of-magic"* (PT, 592).
- *"I give you the Crown of Upper Egypt, the Eye which went up from your head; I give you the Crown of Lower Egypt, the Eye which went up from your head"* (PT, 641; CT, 42).

The Double Crown inspired the Wedjat and Eye of Horus, which inspired much Osirian mythology.
The Wedjat's 4 positions are:
Horus' right eye (Sun) – Horus' left eye (Moon) – legless Seth/Anubis – the Double Crown.

A final few words about the Eye of Horus. It was used in the funerary texts as a metaphor for water, ointment, efflux (fluid released from a corpse), and perfume.

Egyptians had an ambivalent relationship with water; even the inundation had both positive and negative aspects. The Nile was Egypt's life-blood, fertilizing and watering their crops. It was their primary mode of transportation, enabling them to float enormous granite blocks five hundred miles downstream. However, the Nile was also home to killer hippopotamuses and crocodiles, and it was inclined to flood. Egyptians lived on a narrow strip of land squeezed between 2 powerful forces, the Nile and the desert.

Nun, the Waters of Chaos (includes all water) ancient Egyptians thought surrounded their world, threatened to wash away their homes with every storm and flood. On the positive side, however, *"Nun had a rejuvenating, baptismal quality essential to rebirth"* (**G**oelet, 143), particularly in relation to the Sun's daily rebirth. *"While in the Underworld, the Sun would be rejuvenated by the waters of Nun"* (ibid, 153).

The Eye of Horus had the power to revive the dead as food and drink, by cutting open his or her mouth, or by filling them with sacred ointment. That sacred oil was also said to be perfume, which was especially valued for its ability to mask death odors (efflux).

The inundation was thought to be Osiris' efflux because it was preceded by a tumbling wave of foul-smelling, rotting vegetation. *"For several days the Nile would smell so foul with this decaying vegetable matter that the Gods, man and demons stood aghast"* (Naydler 1:6).

Water:
- *"I give you the Eye of Horus; quench thirst with it"* (CT, 936).

Ointment:
- *"Horus has filled his Eye with ointment"* (CT, 845).

Perfume:
- *"The perfume of the Eye of Horus is diffused over you"* (PT, 25, 26).

Efflux (fluid released from a corpse):
- *"Remove the efflux which exuded from your flesh, you being filled and provided with the Eye of Horus"* (CT, 785). The Eye of Horus removes/replaces efflux.

Cheatin' Heart

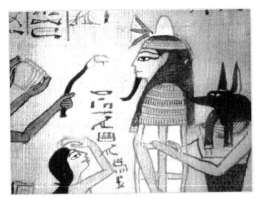 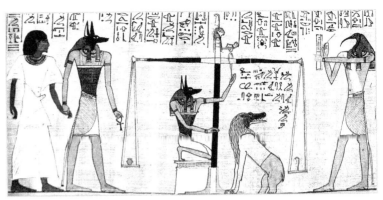

The Opening of the Mouth Ceremony involved holding something up to a mummy's mouth, or to a representation of the deceased (left) to induce him or her to open their mouth and revive. Usually, food, drink, or a symbolic cutting tool were used. Once revived, the deceased was led by Anubis past 42 Assessor Gods to the Weighing of the Heart Ceremony where his or her heart was weighed against a feather of Maat.

Weighing of the Heart Ceremony. Anubis holds the deceased's hand and leads him to the scales. In his other hand, he holds an Ankh, symbol of life. Ammut, the heart-eating monster (combination crocodile, lion, and hippo), eats any hearts that weigh more than the feather (i.e. are sinful), and those people cease to exist.

On-the-level

Out-of-level scales can accidently give damning results. And, to hold the chains or trays invalidates the results.

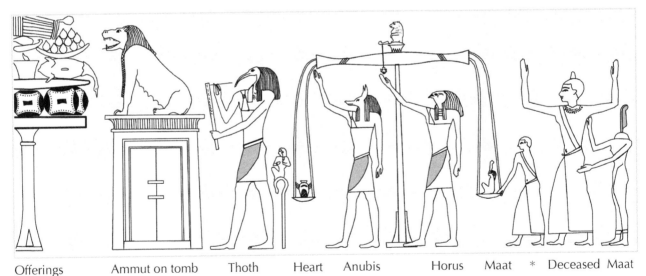

| Offerings | Ammut on tomb | Thoth | Heart | Anubis | Horus | Maat | * | Deceased | Maat |

Cheating at the Weighing of the Heart Ceremony. In this copy, Horus checks the scale's plummet while Anubis assists and Thoth keeps a record. A sumptuous table of food offerings is used to distract Ammut. On closer inspection, Anubis is holding up the scales on the heart side so it will not sink and condemn the deceased. The one-armed figure (*) in front of the deceased is holding down the Maat side of the scales for the same reason. The deceased has a Resurrection Bud on his head and holds his hands up as if to say, "I'm not touching the scales." Behind him, Maat attests to his honesty. Why then is his heart so terrified?

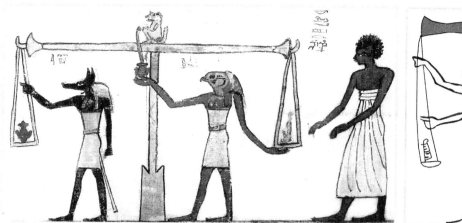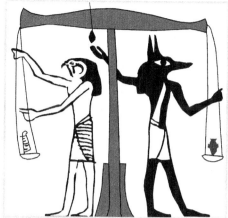

More cheating: a) Anubis holds down the heart while Horus holds up the feather. The symbols are reversed – usually, the heart is held up and the feather down. The artist appears to have made a mistake, because the deceased stands on the right, ready to correctly hold *down* the feather in the event of a heavy heart. However, this may also be the heart of an unusually good man. **b)** Dishonest example: Horus holds down the chains on the Maat feather side with both hands so firmly they bend while Anubis holds the chain on the heart side and turns his back on the plummet, which he should be checking. This widespread cheating has gone unnoticed, as ancient Egyptians would have wished. Given the importance of the outcome, it's certainly understandable they would want all the advantages they could afford.

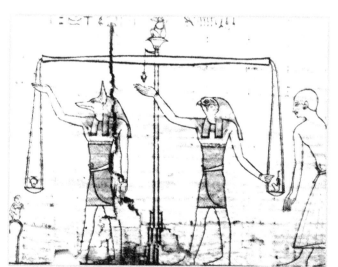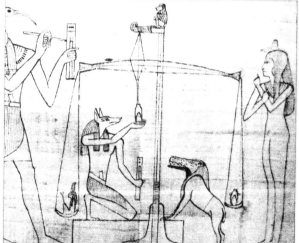

Horus checks the plummet while also holding onto the chain. The plummet shows if the scales are on-the-level. The deceased leans in from the right, ready to intervene. **Right:** an honest weighing. It appears the feather is starting to outweigh her heart.

The Solar Boat carries the 'light-hearted' to their new homes among the circumpolar stars.

Book Summary

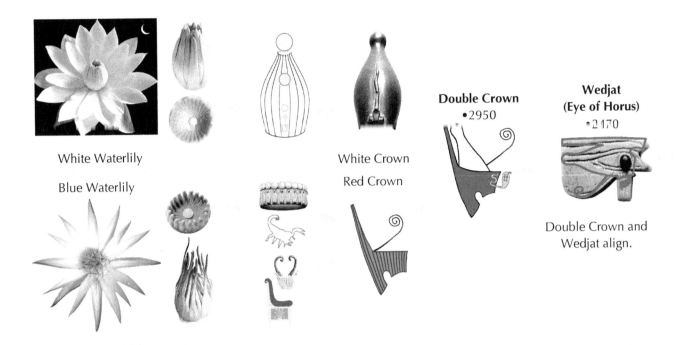

White Waterlily

Blue Waterlily

White Crown
Red Crown

Double Crown
•2950

**Wedjat
(Eye of Horus)**
•2170

Double Crown and
Wedjat align.

Waterlilies – Double Crown – Wedjat

*"The intact **Eye of Horus**, namely the **White Crown**."*
*"The **Eye of Horus**, the **Red Crown** rich in power and many-natured"* (PT, 468).

Ancient Egypt has intrigued Westerners for more than 2 centuries, ever since the artists and scholars of Napoleon's 1798 invasion of Egypt returned to France with fascinating artifacts, drawings, and paintings. Since then, tens of millions of people have visited Egypt's ancient temples and pyramids, and millions more saw Tutankhamun's golden treasures when they twice toured the world.

Many key symbols in ancient Egyptian art have proven enigmatic, and their sources and meanings have remained elusive. As part of a search for the sources of those symbols, the 2 Ancient Egyptian Sacred Waterlilies were examined – for the first time. Then, ancient Egyptian symbols resembling parts of the Waterlilies were identified.

Ancient Egyptians believed things resembling each other were related. Inside the Blue Waterlily, seated on a velvety yellow cushion is a tiny translucent orb that appears to be glowing, which is why Egyptians believed the Sun came from the Waterlily (micro/macro). Resemblance and resurrection are the book's main themes. Resurrection, the reason Egyptians built their tombs and temples, is also richly reflected in their symbolism.

The Waterlilies were valued as a source of food and medicine, and they became ancient Egypt's principal source of resurrection symbolism. Although the Sun Disk was ancient Egypt's most revered life/resurrection symbol, Waterlilies each include a Sun and are also beautiful, varied, and the Blue is fragrant.

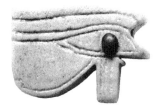

SETH/Anubis
legless = wounded

EYE OF HORUS
Right Eye, Sun Seth face down Left Eye, moon

DOUBLE CROWN
Seth upside-down

WEDJAT'S 4 POSITIONS	
	• **DOUBLE CROWN** position: Wedjat's source, United Egypt, Seth upside-down.
	• **2 EYE** positions: left/moon & right/Sun; Seth face down, castrated in myth.
	• **SETH/Anubis** position: Horus' Eyes vanish, gouged out in myth.

None can be eliminated without eliminating them all.

Wedjat – Horus/Seth – Myth

A direct path can be traced in Egyptian symbolism from the 2 Waterlilies, through the Double Crown to the Eye of Horus and Seth. Ancient Egypt's 3 most important crowns were the White, inspired by the White Waterlily's stamen cluster; the Red, inspired, in part, by the Blue Waterlily's stigmatic basin, and the Double Crown, which combined the 2 and symbolized united Egypt. Egyptian funerary texts identify the White and Red Crowns, both singly and together, as the Eye of Horus.

The Double Crown preceded the Eye of Horus by ~500 years and was its inspiration. Their resemblance is striking; all their major features align, including their identical curls, which fall in exactly the same spot inside each design. The Eye of Horus symbolizes "made whole *again*," or resurrection, because Horus' eyes, in myth, are restored after Seth tears them out. The Wedjat (Eye of Horus amulet) symbolizes transformation, and when either rotated or turned over, it changes into one of

Seth kills Osiris/earth twice:
1) He drowns him = inundation;
2) He cuts him up = plowing.

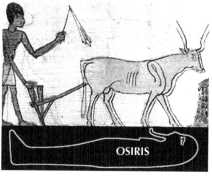

Plow that cuts Osiris = Seth's head.
Osirian myth is based on farming.

4 symbols: Horus' right eye, his left eye, Seth/Anubis' legless bust, or the Double Crown (Seth upside-down). However, only one's perspective changes, not the Wedjat, which suggests that change is an illusion.

Horus symbolizes order, growth and life, whereas Seth represents the opposite, chaos, dissolution, and death. Horus is associated with the Sun, the sky, the Pharaoh and positive things in life. Conversely, Seth, who twice kills his brother Osiris, represents Death and all things negative. Neither Seth/Death nor Horus/Life can defeat the other or exist independently. Horus and Seth coexist in the Wedjat/Eye of Horus as *"opposites in equilibrium"* (**F**rankfort, 21), or dualistically. The Wedjat became ancient Egypt's foremost symbol of healing, dualism, and transformation.

In myth, Osiris is revived and hidden after being drowned by Seth. Nonetheless, Seth finds him and cuts him to death, killing him a second time. Osiris symbolizes fertile land, which the inundation "drowns" annually. After the waters receded, farmers plowed their fields, symbolically cutting Osiris/soil to death. Seth's previously unidentified head was inspired by a plow and bird's beak, by resemblance and relevance. A plow cuts the earth/Osiris, and birds eat/kill his seed. Osirian myth is based on agriculture, Egypt's lifeblood.

It is a beautiful, simple symbolic structure, so logical, obvious and relevant to ancient Egyptians that it endured for 2000 years.

The ancient symbols identified in this book are some of the most important, but were not previously understood. Discovering their sources is an essential part of understanding them. Once done, as Carol Andrews suggests, *"It challenges the world of Egyptology to reassess long-held and clearly incorrect theories about the origin and meaning of so many symbols and representational forms that are fundamental to our understanding of ancient Egypt."*

Opposite: Limestone statue of Rameses II, "Son of Ra," 34 feet tall (was 44), broken at the knees, •1220. Open Air Museum, Mit Rahina, ancient Memphis, Egypt's first capital (see page 122). It and a twin once stood on either side of the entrance to the Temple of Ptah. Sky added.

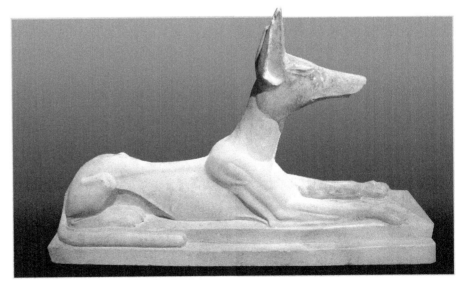

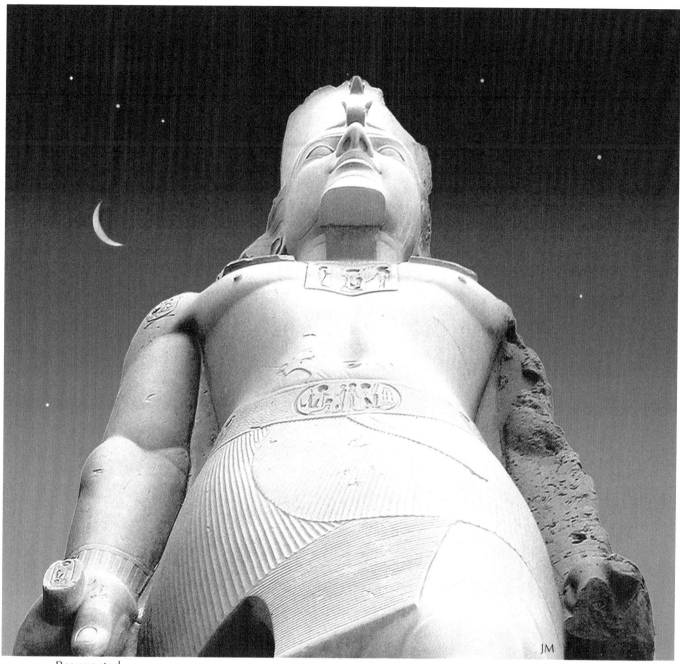

Resurrected

*L*ift up your face, O Osiris; lift up your face, O King, whose spirit goes!
Lift up your face, O King, be strong and effective.
Wash yourself, split open your mouth by means of the Eye of Horus,
Invoke your double as Osiris, that he may protect you from all the wrath of the dead.
O King, take this bread of yours which is the Eye of Horus.

Pyramid Texts, 93

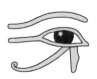

Image Index

1. Blue Waterlily center.
2. Waterlily in Waters of Chaos.
3. Nefertem's Waterlily headdress.
4. Sun-breast from a woman's statue.
5. Blue and White Waterlily symbols.
6. Heraldic Lily + 5 baby crocodiles.
7. Solar Boat + Sun Disk/Cobra-Ring.
8. Scarab pushes up the dawn Sun.

9. Waterlily stem-design game piece.
10. Four Colors = Waterlily symbolism.
11. Uraeus in Four Colors.
12. Cobra-Ring Crown.
13. Stylized Cobra-Ring Crowns.
14. Stylized Cobra-Ring Crown.
15. Stylized Cobra-Ring Crown.
16. Triple Atef w/2 neg.-space H. Suns.

17. Glass fish with water-glyph scales.
18. Cobra-Row in Four Colors.
19. Resurrection Bud on Cobra-Ring.
20. One cobra Cobra-Ring.
21. Stylized Cobra-Row cornice.
22. Waterlily petal mane = Sun face.
23. Tutankhamun born from Waterlily.
24. BWL petal headband implies Sun.

25. Heart with Cobra-Row cornice.
26. Djed Pillar with 4 Cobra-Rows.
27. Heraldic Lily = Blue Waterlily.
28. Heraldic Sun is from Heraldic Lily.
29. Heraldic, Blue, White Waterlilies.
30. Heraldic Lily, royal woman's flail.
31. Heraldic Lily with H. Sun 'flails.'
32. Heraldic Lilies as stylized feathers.

33. Gold glyph = WL, H. Sun drips.
34. Cobra coils form neg. H. Suns.
35. Uraeus is a royal Spitting cobra.
36. Waterlily and papyrus sepals.
37. Waterlily with papyrus sepals.
38. Hathor + Cobra-Ring Crown.
39. Neg.-space Blue Waterlily bud.
40. Sun Disk as mandrake fruit.

41. White Crown = WWL stamens.
42. Atef Crown part of White Crown.
43. Four primary Atef Crown tops.
44. Kheker is a tomb's crown.
45. Binding controls access.
46. Resurrection Bud + Blue WL.
47. Resurrection Bud = egg in nest.
48. Zodiacal light = Cosmic Egg.

GLOSSARY

 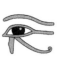 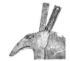

Ammut: heart-eating monster at Weighing of the Heart; part crocodile, lion, and hippo.

Amun Crown: simple, stylized Cobra-Ring Crown, often surmounted with Two Feathers.

Ankh: a life symbol that resembles an Isis Knot. It has a Heraldic Sun head and horizontal arms.

Anubis: jackal god of embalming, represents the human-friendly aspects of Seth/Death.

Apophis/Apep: serpent death-monster that attacks Ra and the Solar Boat at night.

Assessor Gods: 42 Gods who assess the deceased's life and drink *all* the blood of the unworthy.

Atef Crown: White Crown with flanking Maat feathers, also known as Osiris' Crown.

Ba: god's physical manifestation or personality. Five parts of a human: Ba, Ka, body, name, shadow.

Babi: baboon god variation of Seth. "Bull of the Baboons" and an "Outcast."

Bees: Tears of the Sun/Ra. Full bees have a translucent glow like the Waterlily's sun.

Binding: used to symbolically restrict passage. It was added to many symbols.

Blue Crown: war crown, often covered with Sun Disks; inspired by a Sieve Cowry and a turtle shell.

Cobra-Ring Crown: Waterlily-inspired crown base; cobras around a rising Sun = resurrection.

Cobra-Row: side-view of Cobra-Ring, Djoser's Pyramid complex, designed by Imhotep, •2650.

Cosmic Egg: egg from which the Sun was born; Zodiacal Light = eggshell, and yoke = Sun.

Djed Pillar: Osiris' backbone, with 3 Cobra-Rings on top (Waterlilies bloom for 3 days).

Double Crown: Red and White Crowns combined symbolize United Egypt.

Eye of Horus: symbolizes healing, "make whole *again*," resurrection; inspired by Double Crown.

Faience: crushed quartz paste, shaped, and heated until it fuses, hardens, and the surface glazes.

Floral apex: translucent Sun-like orb at a sacred Waterlily's center, part of its ovary.

Four Colors: used to induce Waterlily energy: yellow-white, red, and light and dark blue-green.

Going into the Light: title of misnamed ~~Book of the Dead~~; common near-death experience.

Hathor: cow Goddess of dance, music, and love; her dark side is lioness Sekhmet, the Solar Eye.

Heraldic Lily: stylized Blue Waterlily's side-view, with a rising teardrop Heraldic Sun, often red.

Heraldic Sun: from the Heraldic Lily; an inverted teardrop Sun, and a widely used symbol.

Horus: falcon sky-god, son of Isis and Osiris; his battle with Seth symbolizes Life vs. Death.

Isis: Goddess, sister/wife of Osiris, mother of Horus; her crown is a throne.

Isis Knot: "Blood of Isis" symbolizes a woman's reproductive organs; Heraldic Sun head = uterus.

Ka: spirit, soul, vital force, and one of the 5 elements that make up a person (see Ba).

Kheker: tomb's crown, in rows along the top of tomb walls; Waterlily bud and vulva symbol.

Khnum: ram god who created humans on a potter's wheel.

Maat: Goddess of justice, truth, order; her feather is used in the Weighing of the Heart Ceremony.

Memphis: Egypt's first capital, between Upper and Lower Egypt, now Mit Rahina, near Cairo.

Narmer: one of Egypt's first Pharaohs; his cosmetic palette shows him wearing a White Crown.

Nefertem: Blue Waterlily god and son of Ptah and Sekhmet, wears a Blue Waterlily on his head.

Negative-space: empty spaces between parts of an image, sometimes used symbolically.

Nemes Crown: Djoser's was first; relaxed White Crown less its Sun; it's back inspired by Red Sea seashell.

Nephthys: sister of Osiris, Isis, and Seth, and first mentioned in the *Pyramid Texts*.

Nut: sky Goddess, wife of Geb, swallows Sun at Sunset, gives birth to it at dawn; "heaven's vault."

Osiris: husband/brother of Isis, god of the dead, fertile earth, twice slain by his brother Seth.

Papyrus Column: Life rising from Waters of Chaos; Papyrus Columns supported temple roofs.

Pharaonic: the Pharaonic Period (time of Pharaohs) lasted from •3100–•332 (~2768 years).

Platform Crown: a simple, stylized Cobra-Ring Crown.

Ptah: mummiform creator god of artists and Memphis; consort of Sekhmet, father of Nefertem.

Pyramid Texts: funerary texts carved inside 10 pyramids, •2350⁺; first account of Osirian myth.

Ra: Sun god; Sun at high-noon, its most intense; creator god.

Ra-Horakhty: Horus merged with Ra; Horus was a sky god; his right eye the Sun, left the moon.

Red Crown: Nt, crown of Lower Egypt; inspired by Waterlily, scorpion, horn, red and throne.

Resurrection Bud: Waterlily inspiration; small 'White Crown' with its sun/Sun about to rise.

Sacred Eye: Eye of Horus torn out by Seth; all things positive; the Solar Eye, Horus' right eye.

Scarab: Khepri; inspired by dung beetle; symbolizes Sunrise, pushing up the Sun at dawn.

Scorpion Macehead: large ceremonial macehead, •3000; introduces important symbolism.

Sekhmet: lion Goddess; cow Goddess Hathor's dark side; Eye of Ra and Nefertem's mother.

Selket: one of 4 Goddesses guarding Pharaoh's body; huge, realistic scorpion on her head.

Sepals: the outer petals covering a bud, usually green; especially waterlily/papyrus symbolism.

Seshat: Goddess of writing and builders; lays out temple ground plans; wears a leopard skin.

Seshat's Crown: symbolic marijuana leaf under a breast/Sun symbol.

Seshed's Crown: circlet; Cobra-Ring; headband of gold with Two Feathers and cobra.

Seth: god of chaos, confusion, and Death; kills brother Osiris twice; dualistic balance to Horus.

Shabti: small mortuary statues that magically do work for the resurrected in the afterlife.

Shesmu: winepress god variation of Seth/Death; appears as a lion or lion-headed man.

Shen: circle/Sun with a horizontal line under it, symbolizes eternal life.

Shenu: enlarged Shen, encloses a royal name. Called cartouche before its purpose was known.

Shu: air god; man with raised arms, Sun Disk on his head; sometimes supports night sky.

Sobek: crocodile god; one of Seth's many persona.

Solar Boat: Sun, or Sun in a golden boat; inspired by a Waterlily's center or stigmatic basin.

Solar Eye: Ra's eye; can act independently of him; also lioness Sekhmet, and Horus' right eye.

Solar Disk: encircled by a cobra = Cobra-Ring; all circles are connected to the Sun.

Thoth: Djehuty; god of knowledge, wisdom, and scribes; has 2 forms: ibis and baboon.

Triple Atef Crown: 3 Atef Crowns joined, a feather on either side; some form negative-space Suns.

Uraeus: Spitting cobra on the Pharaoh's brow; Eye of Ra, Sekhmet; an aspect of many crowns.

Wedjat: Eye of Horus amulet; transforms from Eye to Anubis/Seth or Double Crown when rotated.

Weighing of the Heart: deceased's heart weighed against a feather of Maat – lose, and vanish forever.

White Crown: major resurrection machine; inspired by a White Waterlily's stamen cluster.

Zodiacal Light: the dome of light on the eastern horizon, approximately 90 minutes before dawn,
 caused by Sunlight reflecting off the huge dust-field slowly circling the Sun.

BIBLIOGRAPHY

JL

Quotations in this book are followed by the author's name and the page number of their quote in parentheses. If more than one of the author's books are used, book number and page number, in parenthesis, follow their name. Examples: (**Q**uirke, 3:134) and **Q**uirke (3:134).

PT = ***The Ancient Egyptian Pyramid Texts***, translator R. O. Faulkner (Oxford, 1969). •2323–•2100

CT = ***The Ancient Egyptian Coffin Texts***, translator R. O. Faulkner (Oxford, 1973). •2000–•1500

GL = *Ancient Egyptian Book of the Dead*; translator R. O. Faulkner (San Francisco, 1998). •1550–30•

 Going into the Light (**GL**), a more accurate title, suggesting a common near-death experience.

Allen, James P,

 1: *Genesis in Egypt* (Yale, 1988).

 2: *Middle Egyptian* (Cambridge, 2001).

 3: Introduction, *The Ancient Egyptian Book of the Dead* (New York, 2005).

 4: *The Ancient Egyptian Pyramid Texts* (Atlanta, 2005).

 5: *The Art of Medicine in Ancient Egypt* (Metropolitan Museum, NY, 2005).

Andrews, Carol, *Amulets of Ancient Egypt* (London, 1994).

Arnold, Dieter, *Ancient Egyptian Architecture*, translators Gardiner and Strudwick (London, NY, 2003).

Assmann, Jan,

 1: *Death and Salvation in Ancient Egypt* (Ithaca, London, 2001).

 2: *The Search for God in Ancient Egypt*, translator David Lorton (Ithaca, London 2001).

Campbell, Joseph, *The Power of Myth* (New York, 1988).

Clark, R. T. Rundle, *Myth and Symbol in Ancient Egypt* (New York, 1991).

Conard, Henry, *The Waterlilies* (Washington, 1905).

Dorman, Peter, et al; *The Metropolitan Museum of Art, Egypt and the Ancient Near East* (NY, 1987).

Frankfort, Henri

 1: *Kingship and the Gods* (Chicago, 1948).

 2: *Ancient Egyptian Religion* (New York, 2000).

Frazer, James George, *The Golden Bough* (New York, 1947).

Goelet, Ogden, Introduction and Commentaries, *The Egyptian Book of the Dead* (San Francisco, 1994).

Hornung, Erik, *Conceptions of God in Ancient Egypt*, translator John Baines (New York, 1982).

Landon, Ken, personal correspondence (2004 - 2015).

Lurker, Manfred, *The Gods and Symbols of Ancient Egypt* (London, 1980).

Manniche, Lisa,

 1: *An Ancient Egyptian Herbal* (London, 1989).

 2: *Sacred Luxuries* (Ithaca, New York, 1999).

Mercatante, Anthony, *Who's Who in Egyptian Mythology* (New York, 1978).

Metropolitan Museum, **R**igault, Patricia. et al., *Egyptian Art in the Age of the Pyramids* (NY, 1999).

Mojsov, Bojana, *Osiris,* (Australia, 2005).

Naydler, Jeremy

 1: *Temple of the Cosmos* (Vermont, 1996).

 2: *Shamanic Wisdom in the Pyramid Texts* (Vermont, 2005).

Pinch, Geraldine, *Magic in Ancient Egypt* (British Museum, 1994).

Quirke, Stephen

 1: *The British Museum Book of Ancient Egypt*, chapter 3 (London, 1992).

 2: *Ancient Egyptian Religion* (London, 1995).

 3: *The Cult of Ra, Sun-Worship in Ancient Egypt* (London, New York, 2001).

Schneider, Hans, *Life and Death Under the Pharaohs* (Leiden, 2003).

Shaw, Ian and **Nicholson**, Paul, *The British Museum Dictionary of Ancient Egypt* (London, 1995).

Spencer, Neil, British Museum (personal correspondence, 2007).

Te Velde, Herman, *Seth, God of Confusion* (The Netherlands, 1967).

Wilkinson, Richard

 1: *Reading Egyptian Art* (London, New York, 1992).

 2: *Symbols & Magic in Egyptian Art* (London, New York, 1994).

 3: *The Complete Gods and Goddesses of Ancient Egypt* (London, New York, 2003).

Muzzled crocodile, crow, and a Ba bird on an Isis Knot.

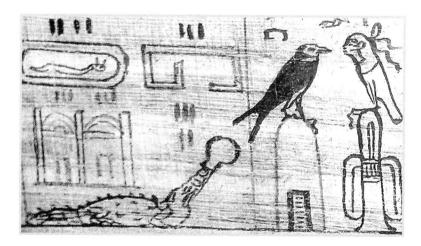

The earth has opened its mouth for me…I have died the death, I have returned alive.

Coffin Texts, 515

Ken Landon

Wagih Issa

Carol Andrews

Barbara Demeter at the Memphis Open Air Museum and sailing on the Nile.

James P. **A**llen

Jonathan Meader: cool drink and interrupted flying lessons (3).

Hans **S**chneider

P.J. Bomhof

These people all kindly helped us.

Jürgen Liepe

Jan **A**ssmann

Herman te **V**elde

Jacobus van Dijk

123

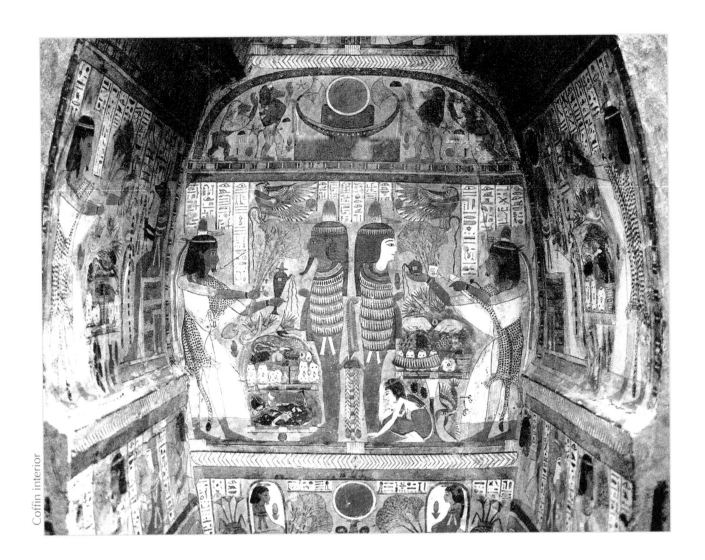

Coffin interior

I have appeared as a great falcon.

I am becoming a God.

CT (149, 214)

JM

Do not go where the path may lead,
go instead where there is no path and leave a trail.

Ralph Waldo Emerson

I think wherever your journey takes you, there are new Gods
waiting there with divine patience – and laughter.

Susan Watkins

CPSIA information can be obtained
at www.ICGtesting.com
Printed in the USA
FSOW03n1434080616
21306FS